IMAGES
of America

NEWBERG

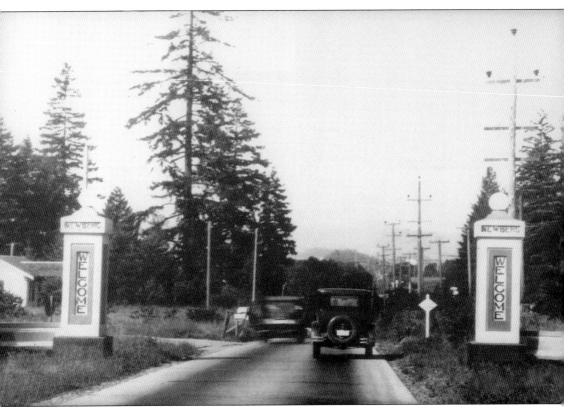

The welcome gates to the city of Newberg were erected by the Newberg Commercial Club at a cost of $800 and placed along Oregon State Highway 99W at the south end of town. The monuments were lit so the "Welcome" and "Newberg" inscriptions could be seen at night. Harlan Smith, a Newberg contractor, installed the signs. (YG)

ON THE COVER: This photograph of the Newberg Cyclery was taken around the 1920s. The shop also sold Harley Davidson products. During that period, Harley motors were attached to bicycles. Thomas Duncan owned Newberg Cyclery. Here some of his descendants pose in front of the shop at 721 First Street. (CITY)

IMAGES of America
NEWBERG

Tom Fuller and Christy Van Heukelem

ARCADIA
PUBLISHING

Copyright © 2010 by Tom Fuller and Christy Van Heukelem
ISBN 978-0-7385-8139-2

Published by Arcadia Publishing
Charleston, South Carolina

Printed in the United States of America

Library of Congress Control Number: 2010926987

For all general information, please contact Arcadia Publishing:
Telephone 843-853-2070
Fax 843-853-0044
E-mail sales@arcadiapublishing.com
For customer service and orders:
Toll-Free 1-888-313-2665

Visit us on the Internet at www.arcadiapublishing.com

This book is dedicated to the citizens of Newberg and the families who have kept alive its history, its culture, and its beauty.

Contents

Acknowledgments		6
Introduction		7
1.	Territory to Town	9
2.	Friends and Pacific College	23
3.	Street Scenes	39
4.	Schools and Churches	51
5.	Creating a Town	65
6.	Building a City	81
7.	Helpers and Healers	101
8.	Faces and Places	113
Bibliography		126

Acknowledgments

The authors would like to acknowledge the assistance of the following individuals and organizations, without whom this project would not have been possible: Zoie Clark, Ralph Beebe, and Rob Felton of George Fox University; Marjorie Owens of Yamhill County Historical Society; Leah Griffith and Denise Reilly of the Newberg Public Library; Claudia Stewart and Pamela Hermanson of Newberg Public Schools; Dan Linscheid of the Yamhill County Historical Society, for the 2002 digital photographs; Mark Cooke and Tim Weaver of the Newberg Police Department; Chris Mayfield and Jill Dorrell of the Newberg Fire Department; Barton Brierley of the City of Newberg; Providence Newberg Medical Center; Newberg Friends Church; Patrick Murphy of Yamhill Grill; and the *Newberg Graphic*.

The following individuals shared the Newberg of yesterday through personal collections: Todd Scharff; Dennis Cooke; Gary Fendall; Teresa Allen; Ken Austin; Loni Parrish; Sherrie, Jay, and Norma Hopkins; Floyd Watson; Loren Mills; Helen Cadd; Sherry Oakley; Jim Smeed; Virginia Jungwirth; Leonard Johnson; Dave Daniels; Wayne Roberts; Pamela Weaver; Kathleen Macken; and Irene Tessman.

Special thanks to Brian Francis, Al Blodgett, and Leah Griffith for willingly sharing their knowledge of the Newberg community and providing encouragement for this project.

For her invaluable assistance in editing the manuscript, special thanks to Maxine Marsolin.

We would also like to thank our editors at Arcadia Publishing, Sarah Higginbotham, Devon Weston, and Donna Libert for their assistance through this project.

The photographs in this book are courtesy of the following organizations unless otherwise noted. Photographic abbreviations used in this book are as follows:

CITY	City of Newberg
GFA	George Fox University Archives
GRAPHIC	*Newberg Graphic*
NFD	Newberg Fire Department
NPL	Newberg Public Library
NS	Newberg Public Schools
PNMC	Providence Newberg Medical Center
YCHS	Yamhill County Historical Society
YCHS-DL	Yamhilll County Historical Society, digital images 2002, Dan Linscheid
BF	Brian Francis
DC	Dennis Cooke
FW	Floyd Watson
LM	Loren Mills
TA	Teresa Allen
TS	Todd Scharff
WCFC	West Chehalem Friends Church
YG	Yamhill Grill

Introduction

A 1922 brochure described Newberg this way: "Our city, nestled in the beautiful Chehalem Valley—"Valley of Flowers"—caressed by the balmy ocean air, guarded by mountains, verdure clad and evergreen throughout the year, from base to summit; blessed with abundant pure mountain spring water; swathed in a sea of roses; lovely vistas, far as eyes can see, of orchards, groves, fertile fields and homey homes, it is Paradise."

Newberg might have been called Chehalem if Joseph Rogers had lived a little longer. Chehalem is the Indian word for "Valley of Flowers." Rogers, one of the first settlers of Newberg, adopted it as a name for the area in 1848. He went so far as to have a town plat made up and recorded in Oregon City, but passed away before the name, or the town, took root. The man who had the honor of providing the town's name was Sebastian Brutscher, a Bavarian immigrant who started the first post office in his home. Ironically, even Brutscher wrote "Chehalem" on a tax receipt envelope.

In the beginning, Newberg was not considered "paradise" so much as wilderness. Pioneers described it as "a grassy wilderness dotted with oak trees, with Douglas fir scattered along the streams, surrounded by almost treeless hills." The roads were nothing more than rutted Indian trails running up and over the gap between Chehalem and Parrett Mountains. A small village of the Yamhelas tribe camped near Chehalem Creek, subsisting on game and durable cakes made from the camas root.

In this book, you will discover that the history of the Oregon Territory, as well as Oregon as a part of the United States, is intertwined with the land that became Newberg. Though it never grew into the 50,000-population metropolis some city fathers envisioned, Newberg continues to stamp the region with a unique cultural, economic, and spiritual influence. When settlers first visited the Chehalem Valley, they encountered a land rich with flowers, apples, pears, and berries. In fact, so many blackberries, strawberries, and raspberries grew here that the town created the Berrian Festival to honor the berry. New settlers successfully grew peaches, apricots, plums, and prunes. When the ground failed to continue producing berries, farmers turned to growing hazelnuts. Despite fighting blight, Oregon still provides 99 percent of the hazelnuts grown in the United States. As the years passed, some farmers started growing another tree crop, Christmas trees. For years, one could scarcely drive a few feet outside the city limits without being surrounded by Christmas tree farms. Today yet another crop is replacing some of those farms. Instead of Douglas fir trees, the hillsides of the Chehalem Valley are now lined with vineyards. Newberg has found itself right in the center of a fast growing wine and grape industry.

In the beginning, it was a failed wheat farm that gave birth to this picturesque city. In 1866, Peter Hagey purchased the northern part of Joseph Rogers's Donation Land Claim. For some reason, Hagey did not have much luck raising wheat, and by 1881, his farm produced very little. At that time, Newberg had an important visitor: Jesse Edwards. Edwards came to the area because he was interested in joining a "colony" of fellow members of the Friends church, started by another pioneer, William Hobson. Edwards purchased Peter Hagey's farm for a mere $25 an acre. The land was near the intersection of two important regional roads, and since the Hagey farm wasn't producing a crop, Edwards concentrated on establishing a town in 1883. After going into business with Hobson's son, Jessie, what was once a farm now had streets and a store. In reality, there were actually two Newbergs springing up at the same time. In 1881, David J. Wood and William P. Ruddick platted a town near Illinois and Main Streets and called it Newberg. The two towns eventually grew together, but in the beginning, they were as different as night and day.

A more conservative group settled "Grubby End" near First and Center Streets. A second, less conservative group settled along Main Street in an area that became known as "Froggy End." This name may have come from the fact that much of early Newberg was a bit swampy during winter. Froggy End had a train depot, a hotel, a saloon, and a store. The rivalry between the two groups was so severe, children were not allowed to go unaccompanied from one settlement to another. As more homes and businesses sprung up between the two towns, the groups eventually stopped fighting, but the influence of the "Grubby Enders" was felt long afterward. When Jesse and Mary Edwards sold some of their land in 1887, they added a clause prohibiting the sale or consumption of alcohol. Newberg remained a dry town for nearly 80 years.

Though most of this book focuses on historic photographs, we have weaved a lot of historical information into the detailed captions. To further enhance your enjoyment of the book, consider taking it on a walking tour of downtown and viewing historic buildings in their modern context. You can also begin to look for some of the names in this book on street signs and on public buildings, like schools. It might be fun to stop by some of those historical sites and show the owners a picture of their building in former days. As you drive along First Street, recognize that you are traversing the historic dividing line between the Donation Land Claims of Joseph Rogers and Daniel Deskins. Main Street divides the claims of Rogers, John H. Hess, and Deskins, while Villa Road is the boundary between the Deskins claim and that of John Everest.

Today Newberg is a very modern city, connected by road, rail, and high-speed internet, yet it has maintained its small town charm. Along the tree-lined streets, onlookers can still view some of the homes built by Newberg pioneers. The cars have changed, but many of the buildings of downtown remain as they were a hundred years ago. Newberg is only minutes away from Portland, McMinnville, and Salem. Perhaps its proximity to larger communities has enabled it to retain some of the atmosphere that made it so attractive. The beauty of Chehalem Mountain, the majesty of the gently rolling Willamette River, and the softly waving fields of wheat along North Valley Road make up the charming home we call Newberg.

One

Territory to Town

For thousands of years, the rich prairies and oak savannahs of the Willamette River Valley provided home and sustenance to families of Native Americans, known collectively as the Kalapuya. One of their villages, Cham-ho-huo, sat next to Chehalem Creek near the present city of Newberg. Yearly burning of those prairies provided roasted tarweed pods, but also drove huge numbers of wild game into the open where they could be hunted easily. Without intending to, these land management practices, along with river flooding, prepared some of the richest soil for farming in the world.

In 1813, trappers out of Fort Astoria, in need of additional food sources to supplement their diet of salmon, hunted for beaver and bearskins along the Willamette. They eventually set up camp in a place that years later would be called Newberg. In 1834, one of those trappers ended up in the Chehalem Valley. Ewing Young claimed all his eyes could see from the Dayton Hills to Chehalem Mountain. Young drove 630 head of cattle to the area, built a mill on Chehalem Creek, ran a store, and raised horses. Though no photograph of Young survives, his legacy lives on in Newberg and Oregon. Young died without a will in 1841. The gathering at Champoeg to settle his estate led directly to a historic vote on May 2, 1843, steering Oregon to become a part of the United States.

The Donation Land Act of 1850 provided a square mile of land per couple and attracted people like John and Joseph Hess to the area. Sebastian Brutscher opened a post office along what would be Portland Road, and William Hobson began to encourage Quakers to settle here in the 1870s. Jesse Edwards bought a 184-acre worn-out farm that was carved out of two Donation Land Claims. He platted a town and sold land for $100 a foot. The population grew rapidly, along with the need for public services. Finally, on February 21, 1889, the Oregon legislature passed a law and the city of Newberg was born.

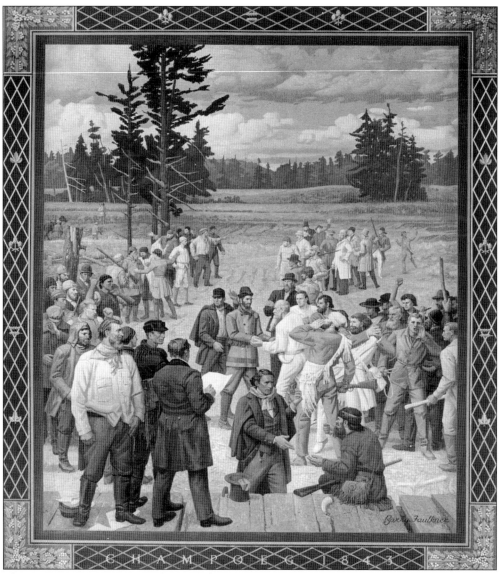

This painting commemorates the crucial meeting that took place in Champoeg on May 2, 1843, when settlers of the Oregon Country voted to create a provisional government and join the United States. The precursor to that meeting was the settling of the estate of Ewing Young, the first Caucasian settler on the west side of the Willamette River. Young claimed all the property in the Chehalem Valley and raised numerous cattle and horses. Among the wave of settlers was Sidney Smith. Smith joined up with Young and upon his death became secretary of a meeting to discuss Young's estate. Smith purchased the property, and the money was used to build the first jail in Oregon, located in Oregon City. (Courtesy of Oregon State Archives)

Ewing Young started a still somewhere in this area near Newberg as a form of revenge to Dr. John McLoughlin, who had called Young a horse thief. Young supplied liquor to French-Canadian trappers, but the temperance society of the Jason Lee Mission in Salem convinced him to switch to cattle raising. (YCHS-DL)

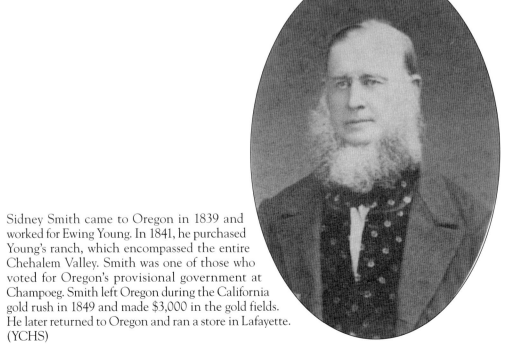

Sidney Smith came to Oregon in 1839 and worked for Ewing Young. In 1841, he purchased Young's ranch, which encompassed the entire Chehalem Valley. Smith was one of those who voted for Oregon's provisional government at Champoeg. Smith left Oregon during the California gold rush in 1849 and made $3,000 in the gold fields. He later returned to Oregon and ran a store in Lafayette. (YCHS)

Joseph Hess was among many early settlers who came to Oregon in 1843. He built a flour mill along Hess Creek that runs through the George Fox campus. Hess eventually owned nearly 1,000 acres and was among the wealthiest of men in the Chehalem Valley in 1870. The Hess land claim was located northwest of present Newberg. (GRAPHIC)

This document shows the layout of Donation Land Claims (DLC) for the area around Newberg. William Jones, John H. Hess, David Ramsey, Oliver J. Walker, Daniel D. Deskins, Joseph Rogers, and Richard Everest are listed. A married couple could possess 640 acres if they farmed the land. Property lines changed often, and Newberg was created out of the Rogers DLC. First Street divides the Deskins and Rogers DLC. (Courtesy of Leonard Johnson)

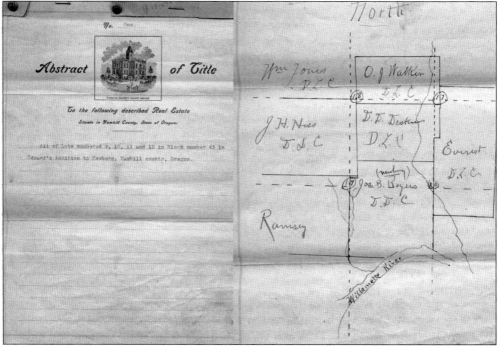

David and Susan Ramsey owned 644 acres of land along Chehalem Creek. Ramsey opened a sawmill along the creek in 1849. In 1857 he built what is thought to be the first frame house in Newberg, south of Dayton Road. Ramsey's sawmill was eventually converted to a flour mill. After selling the mill for $2,500, its name was changed to Newberg Flouring Mills. (GRAPHIC)

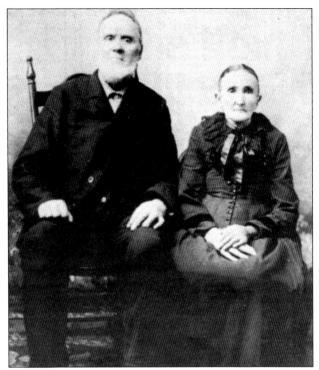

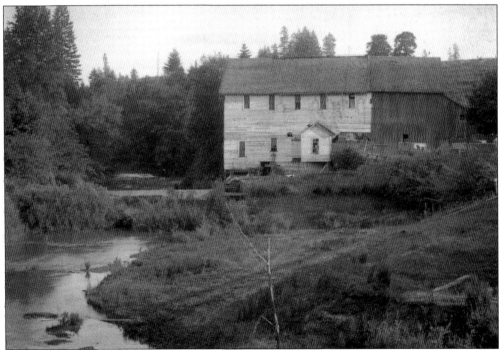

The Ramsey sawmill near Dayton Avenue ran until 1862. It was rebuilt as a gristmill in 1910. Ewing Young also built a mill, as did many others along the small streams around Newberg. Sebastian Brutscher raised a mill near Springbrook. The Dorrace Brothers also erected a mill along the Willamette River, which later became the Spaulding Mill. (YCHS)

Benjamin Heater homesteaded 640 acres northeast of Springbrook, along with his wife Mary Jane. The property was close to Mary Jane's grandfather Jacob Shuck's land. They endured the heavy snow of January 8, 1862, which didn't melt until mid February. Many horses, sheep, and cattle died, while wild deer came to the door begging food. An Indian trail that went from Oregon City to Grand Ronde cut through their land. (YCHS)

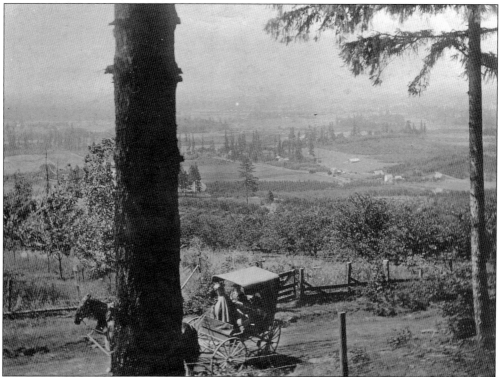

This is an early picture of Newberg, perhaps taken from what would become Highway 219. Many roads were strewn with stumps and were nearly impassable. In those early days, activities around town included drinking, horse racing, and dancing. Newberg was a very small community consisting of a country store and a post office. Mail arrived by horseback only three times a week. (GFA)

On June 14, 1939, this monument was dedicated to the memory of Ewing Young. Young claimed the area of the Chehalem Valley as his own. He died with no will, but left behind a vast tract of land. Settling the ownership of that land led to the first meeting of the provisional government and ultimately to the decision to establish the state of Oregon as a part of the United States. (W. M. Scofield)

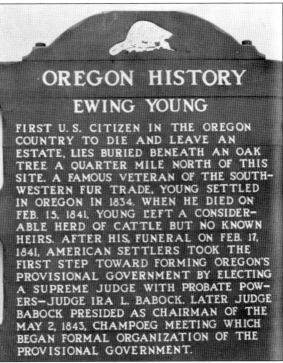

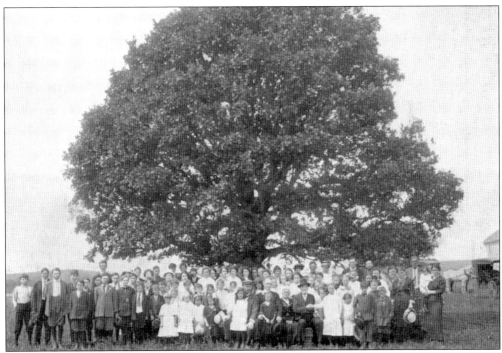

Participants gather at the Ewing Young Oak for the dedication of the Young memorial marker. The tree was planted May 6, 1846, on the site of Ewing's grave. Ewing was the first settler in the Oregon Country independent of aid from the Hudson's Bay Company. His land was some 5 miles wide and 15 miles long. Sydney Smith purchased the property and all the cattle for $200. (NS)

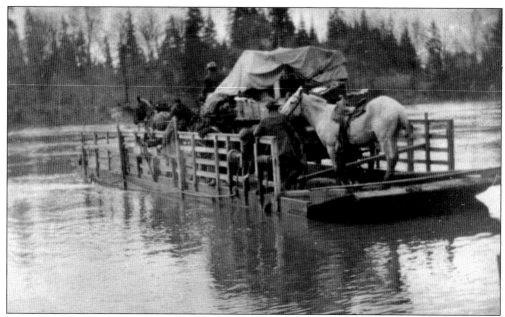

This photograph shows a close-up of Gearin's Ferry as it began its journey across the Willamette River. Aboard is a wagon loaded down with supplies. The driver sits in the wagon to keep the horses calm, while another passenger holds his horse toward the back of the ferry. The ferry was drawn back and forth across the river by rope. (YCHS-DL)

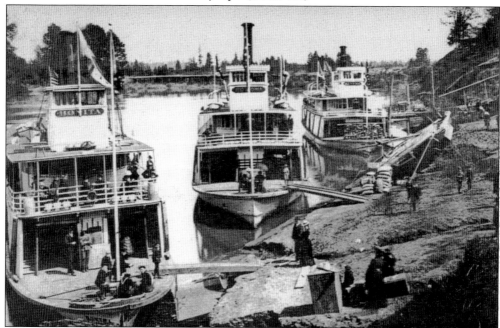

Early transportation from Portland was almost entirely by river. Boat landings were created at Dayton, Wheatland, Champoeg, Butteville, and Newberg. To travel to Portland, a passenger would come to Rogers Landing around 6:30 a.m., and could expect to arrive in Portland between 3:00 and 5:00 in the afternoon. A special boat whistle would alert Newberg businessman Jesse Edwards to hitch up his wagon and pick up freight. (CITY)

As late as 1850, the only way to cross the Willamette was by canoe, raft, or small boat. The first steamboat, the *Hoosier*, arrived at Rogers Landing on May 19, 1851. Before bridges were built to cross the river, ferries took passengers, horses, and freight across. This photograph shows Gearin's Ferry. (YCHS-DL)

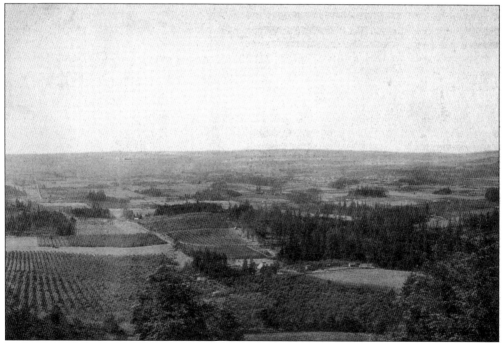

This photograph shows the Chehalem Valley, with Newberg in the distance. Originally the area was a grassy wilderness, dotted with oak and Douglas fir by the streams with treeless hillsides. Cattle raising was the first agricultural activity in the region. As more timber was cleared off, farming of wheat began, which was ground into flour at Oregon City or Lafayette. (LM)

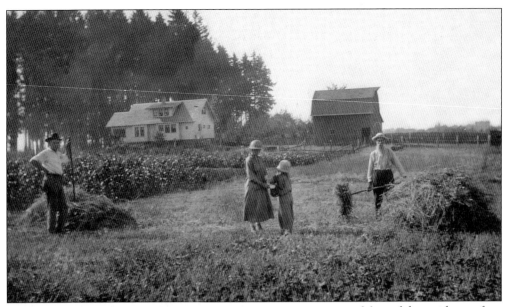

Most of the residents of Newberg in its early days were farmers. Three large land claims spanned most of what would become Newberg. As the land was sold, more farmers arrived, including members of the Friends church. This is a photograph of one such farm. Beginning in the autumn of 1880, members held temperance meetings on the first Sabbath afternoon of each month. (GFA)

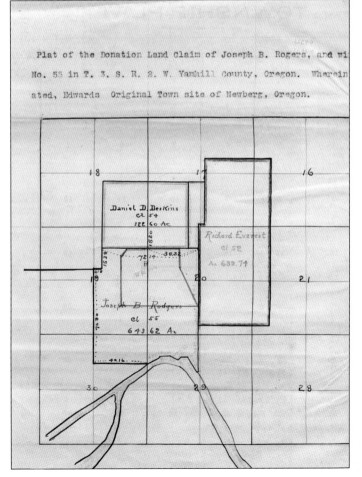

This document contains the plat map for the Donation Land Claims of Richard Everest, Daniel D. Deskins, and Joseph B. Rogers (or Rodgers). Rogers Landing was at the Willamette River region of Rogers's claim. The plat also contains the original layout of the town site for Newberg, as drawn by Jesse Edwards. (Courtesy of Gary Fendall)

This is a portrait of Charles Fendall and Amanda Rogers Fendall. Amanda was cousin to Joseph B. Rogers, whose 1859 land claim became the city of Newberg when Jesse Edwards purchased part of the land. Fendall himself held a 640-acre Donation Land Claim. He built a log cabin on the claim, but traded it for a farm in Willamina few years later. (Courtesy of Gary Fendall)

William Everest and his 19-year-old wife Josie pose for a portrait in 1894. Everest had one of the early 640-acre land claims in Newberg, which stretched from Springbrook south to the Sportsman Airpark. Everest operated a saloon on the Dayton-Portland Road and was a pioneer hop grower and beer producer. He also built a racetrack at the present site of the 99W Drive-In Theater. (GRAPHIC)

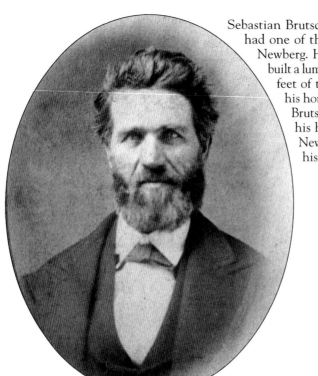

Sebastian Brutscher, an immigrant from Bavaria, had one of the first seven land claims around Newberg. He founded the area's first school, built a lumber mill that produced 75,000 board feet of timber, and set up a post office in his home. The name Newberg came from Brutscher, based on Neuburg on Danau, his hometown in Bavaria. Providence Newberg Medical Center was built on his land in 2006. (PNMC)

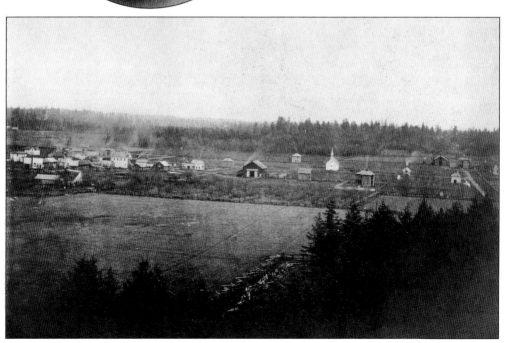

This is a photograph of Newberg in 1887, taken from a vantage point near the center of the present city. At the far right is what would become Hoover Hall of the Friends Pacific Academy. To its left is Jesse Edwards's house and to the extreme right, the home of H. J. Minthorn, the boyhood home of Herbert Hoover. (GFA)

Jesse Edwards, known as the "Father of Newberg," came to Oregon in 1880. He purchased the worn-out farm of Peter Hagey and, because it was so difficult for farmers to get their goods to market, decided to establish a town on his land. He started Pacific Academy two years later and, while raising money for the school, convinced a large number of Quakers to move to Newberg. (TA)

Newberg was famously known as a dry town, one of only two in Oregon. The prohibition on the sale or consumption of alcohol came from this deed of sale by Jesse and Mary Edwards on January 31, 1887. The deed states that if "any spiritous liquors of any kind whatsoever to be drunk or sold," the property would be forfeited. This prohibition was repealed by a vote in 1966. (Courtesy of Gary Fendall)

Sheridan and Elizabeth Calkins pose with their son Dean, who was born in 1890. Sheridan served as mayor of Newberg, a Yamhill County commissioner, and as head of the Berrian organization. Calkins came to Newberg in 1891 and became the proprietor of a furniture store at First and Center Streets. He went into business with L. M. Parker in a general merchandise store and planted the first commercial walnut orchard in the area. (CITY)

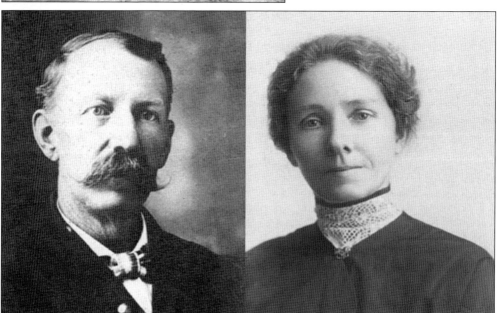

Seven generations of the Austin family have resided in Newberg. Pictured here are Henry Austin and his wife Barbara Eberhard. Henry moved to Oregon in 1876 with his first wife, Mary Hobson. Mary's father, William Hobson, helped establish Newberg as a Quaker community. After Mary's death, Henry married Barbara, whose grandparents, Stokley and Juliza Jones, had come to Oregon in the 1850s by way of the Oregon Trail. (Courtesy of Loni Parrish)

Two

FRIENDS AND PACIFIC COLLEGE

It would be impossible to chronicle the history of the city of Newberg without mentioning the Religious Society of Friends. The Friends, as they have come to be known, have been synonymous with Newberg since its very earliest days. Newberg became the first Friends (or Quaker) settlement west of the Great Divide, thanks in large part to William Hobson. While living in Iowa, Hobson felt a calling to bring "religious service near the Pacific Coast," as he wrote in his diary in September 1870. Hobson looked for a "Promised Land" where other Quakers had not yet settled. After traveling from Dayton and purchasing a 320-acre farm, he eventually found that settlement land to be the Chehalem Valley. On March 19, 1876, he held the first Friends church services and began in earnest to invite other Quakers to join him in Oregon. So many heeded the call that two years later, the Chehalem Monthly Meeting was established.

Before there was a public school system, one of the first Quaker immigrants, Maggie Wood, taught 13 elementary children in her home. As they neared graduation, the need for advanced education was placed before the Monthly Meeting. In 1885, Pacific Academy opened its doors on a site donated by Jesse Edwards with future president Herbert Hoover as one of its first students. After only five years, attendance grew to 130. As the students graduated, the academy realized that the only Friends college available was all the way back in Iowa. In the fall of 1891, Pacific Academy's board opened Pacific College. A group of 15 college students and 136 younger students shared the same buildings, and were taught by the same six professors. By 1892, the two college buildings were moved to their final site. Despite economic and political turmoil, Pacific College slowly grew and expanded its offerings. In 1949, the institution changed its name to George Fox College, named for the founder of the Quakers. After acquiring Western Evangelical Seminary in 1996, the college became George Fox University. The Religious Society of Friends' influence continues at George Fox and at several area churches in Newberg. The church also acts as the headquarters for the Northwest Yearly Meeting.

William Hobson was a devout Quaker who felt a calling to bring "religious service" to the Pacific Coast. Hobson bought 350 acres in what would become the town of Newberg and, on March 19, 1876, held his first Quaker service at the home of William Clemmens. Hobson was instrumental in establishing the Quaker settlement of Newberg. He is still considered an influence to this day. (LM)

Prof. George Hartley and his wife, Etta, sit outside of their home east of Wynooksi Creek Canyon in 1891. Professor Hartley accepted a bear caught by Pacific Academy student Reuben Frank. Named Bruin, the bear lived in a pit but escaped several times. The pelt of the bear was eventually placed in a museum when Pacific College opened on September 9, 1891. (GFA)

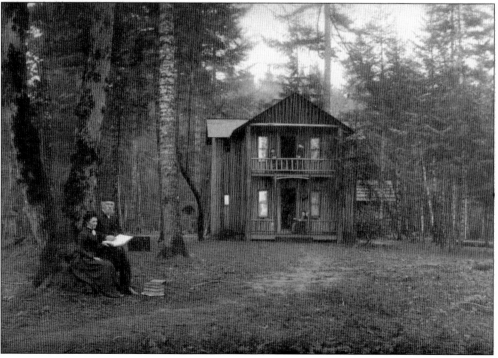

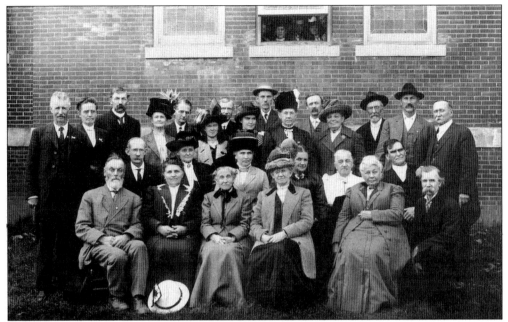

As word spread about Newberg, more Quaker settlers arrived. On June 1, 1878, the Chehalem Monthly Meeting was created. In 1886, the name was changed to the Newberg Monthly Meeting. This is a photograph of the 1893 Yearly Friends meeting. The Quakers brought a more law-abiding, religious element to a town where drinking, horse racing, and "carousing of various kinds" was common. (GFA)

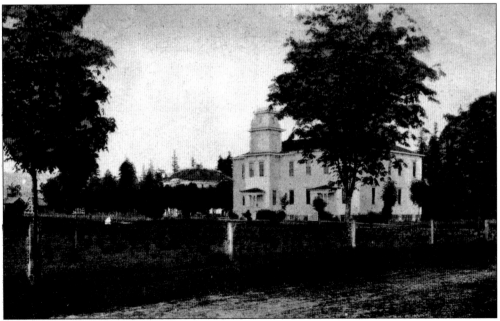

This is a postcard of Pacific College as it looked around 1893. The large building was known as "College Building," later renamed Hoover Hall. The first floor contained a chapel, while the second floor provided classroom space. The basement served as an exercise room for young men in inclement weather. Kanyon Hall sits in the background to the left. (LM)

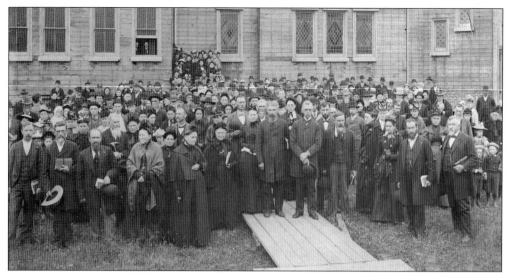

Several hundred Friends from the 1894 Yearly Meeting gather outside of the Newberg Friends Church for a photograph. Only a year earlier, the Oregon Yearly Meeting gained independence from the Iowa Yearly Meeting. Most Friends immigrated to Newberg from Iowa and Indiana. They felt it was the "Promised Land." By the end of the 19th century, some 800 Quakers had moved to Oregon. (GFA)

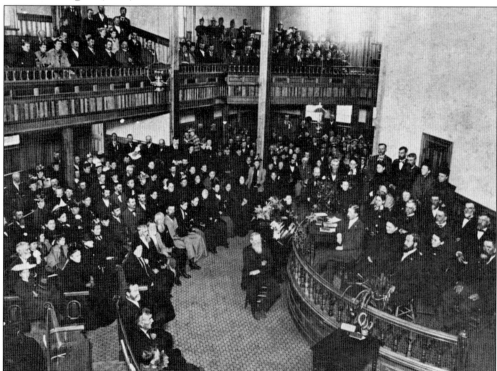

This photograph shows the Yearly Meeting of Friends from 1894, in the brand new Newberg Friends Church. By that year the Friends in Oregon had grown to seven "monthly" meetings with a total of 1,363 members, with the largest in Newberg. In 1893, the organization became known as the Oregon Yearly Meeting (later changed to Northwest Yearly Meeting). (LM)

In 1880, Jesse Edwards moved to Newberg and purchased 184 acres from the Peter Hagley farm, which was part of the Rogers Donation Land Claim. Edwards built this house in 1883. The 2,550-square-foot Victorian house was used as an early meeting place for incoming Quakers. It was moved 100 feet to allow for a street expansion and now serves as the residence of George Fox University's president. (GFA)

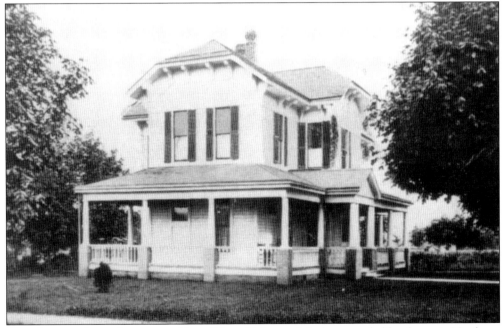

This photograph is a closer view of Jesse Edwards's home. It is the second oldest home in Newberg, after the Hoover-Minthorn house. The home was purchased by descendants of the Edwards family, who gave it to George Fox University in 1998. It features a wraparound porch, turned Tuscan Doric porch columns, a distinctive gable roof, and bracketed cornices. (YCHS-DL)

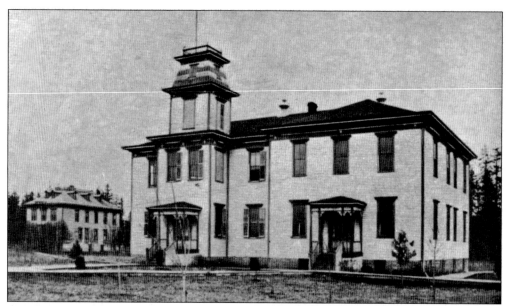

This is a closer view of "College Building," which was later called Hoover Hall. This was the entire campus from 1895 to 1911. Though the second floor was to be used for classrooms, the *Newberg Graphic* reported, "This will give the young ladies a room in which they can swing Indian clubs to their hearts content on rainy days during the winter." The building was razed in 1954. (GFA)

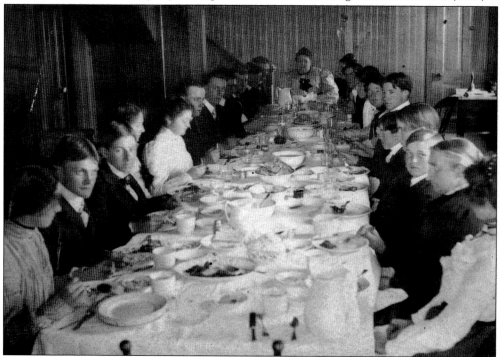

This photograph shows the first dining room at Pacific College, taken in 1893. Thomas Newlin was the college's first president. When the college opened in 1891 it featured classes in philosophy, political economy, Latin, Greek, English, mathematics, and music. Tuition was $8 to $12 per term, plus $2.50 per week in the College Boarding Hall. (GFA)

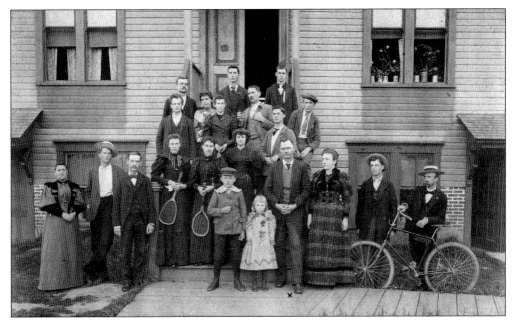

This is Kanyon Hall in 1895 or 1896. Mrs. Chas Johnson is listed as matron. The building was first constructed in 1887 and later renovated and expanded. It is the oldest building on the George Fox University campus. Herbert Hoover is believed to have lived here for a few months in 1888. When this photograph was taken, the structure was being used as a women's dormitory. In the 1960s, Kanyon Hall was renamed Minthorn House. (GFA)

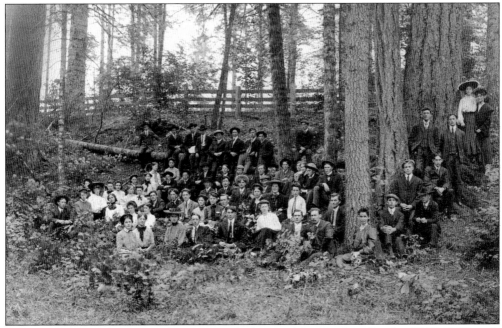

This photograph appeared in the centennial edition of the *Newberg Graphic* (1805–1905) with the caption, "Picnicing in shade of big trees in college campus." Some of the recognizable names in the photograph are: Edwin McGrew, college president; Mary Minthorn; Cecil Hoskins; Perry Macy; Vivian Hadley; and Mabel Gardner, the future Mrs. Cecil Hoskins. (GRAPHIC)

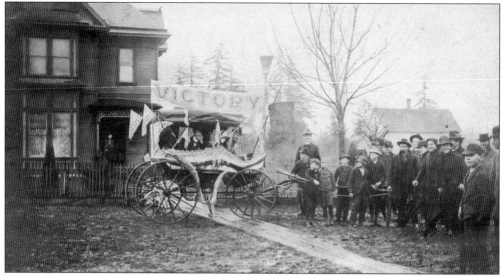

This is a 1901 photograph of Newberg residents giving a hero's welcome to Elwood Minchen, winner of an oration contest. The 1901 Oregon Intercollegiate Contest was equivalent to a state championship. Minchin was a freshman at Pacific College at the time. For the celebration, local businesses shut their doors and residents gathered at the train depot to welcome their hero and parade him through the streets. (GFA)

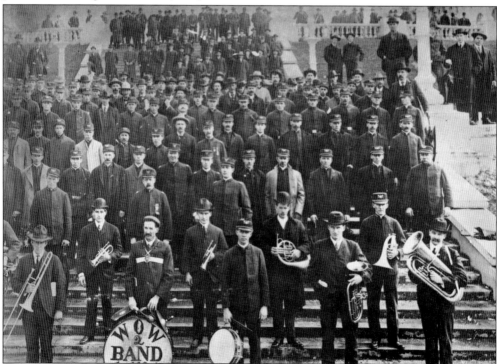

This is the first Pacific College band in 1905. The Woodmen of the World provided the members their band uniforms as they performed at the Lewis and Clark centennial in Portland. At this time, oratory contests were one of the main competitions. Sophomore Walter R. Miles won the national contest of the Prohibition Colleges in 1904. (GFA)

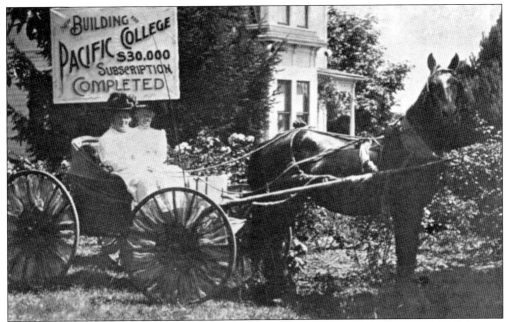

In 1910, Pacific College needed to expand. Newberg's mayor launched the campaign in February, and residents subscribed $16,335. That wasn't enough, so Evangeline Martin and Amanda Woodward, long-time Quakers and college supporters, rode "Faithful Old Kit" through the streets, canvassing businesses and signing up 600 donors. They are pictured celebrating the success of their campaign on July 4, 1910. (GFA)

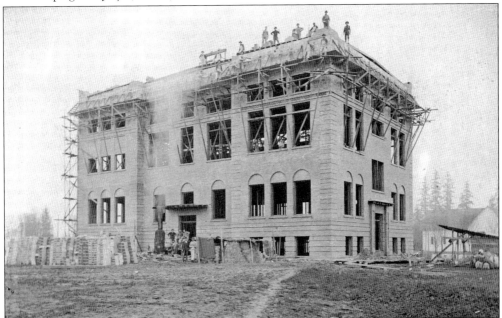

The funds raised by Evangeline Martin and Amanda Woodward were used to construct Wood-Mar Hall. This photograph shows the building under construction in 1910. The cost for construction was $30,000. It was completed within a year, and the board of the college honored the two women and their extraordinary fund-raising efforts by naming the building after them. (GFA)

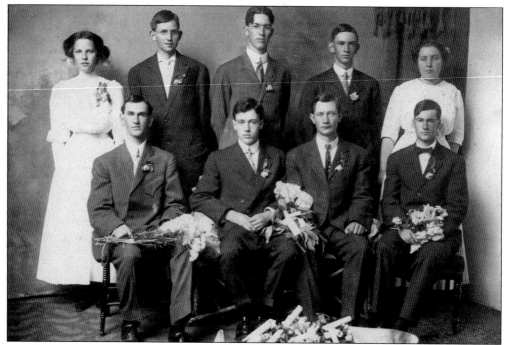

Above, the Pacific Academy graduating class of 1911 poses for a portrait. Enrollment that year was 41. Pictured are, from left to right: (seated) Olin Hadley; Harry H. Haworth, W. Ellis Pickett, and unidentified; (standing) Eva (Campbell) Knight, Meade Elliott, Tom Arthur Benson, Clifford Hadley, and Gladys (Hannon) Keyes. It was around this time that the college raised its first endowment of $119,000. (GFA)

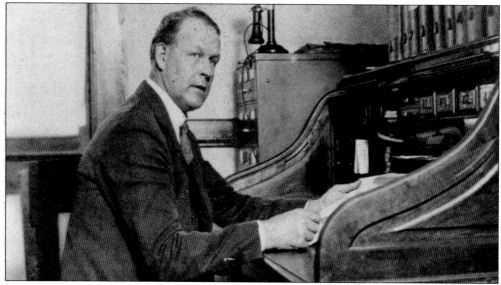

Dr. Levi Pennington served as president of Pacific College (now George Fox University) from 1911 to 1941. Pennington was a prolific letter writer, often penning 1,500 letters a year. Among his correspondents was Herbert Hoover, one-time Newberg resident and 31st president of the United States. Pennington was known for his great love and encouragement of others. He died in Newberg at the age of 99 in 1975. (GFA)

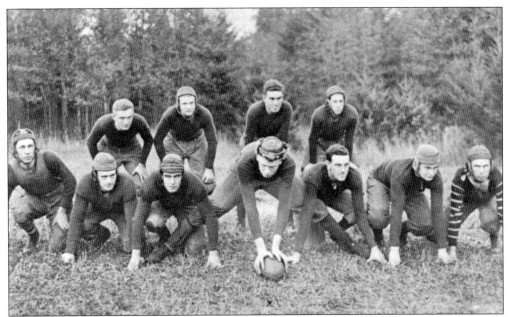

Pictured here is the 1915 Pacific College football team. The institution had a football program from 1894 to 1968, except for a brief period during the 1920s. During this time, Pacific earned several titles. The 1917 basketball team won the Willamette League Championship, and the 1924 baseball team also won its league championship. In 2010, Fox began plans to reinstate a football program. (GFA)

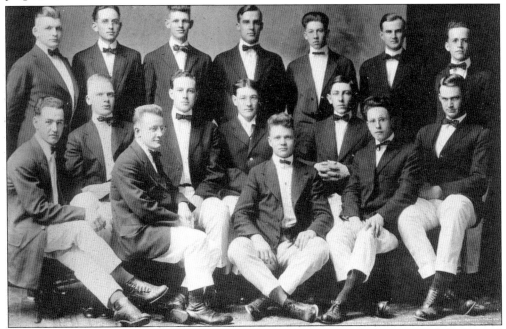

This is the 1916 Pacific College Men's Choir. As the college struggled to pay the bills (annual salaries amounted to $6,900), enrollment continued to climb. A total of 54 students attended in 1917, but the student body was cut in half during World War I. Because of its pacifist stand, 25 students provided war relief efforts—more than any other college in the world. (GFA)

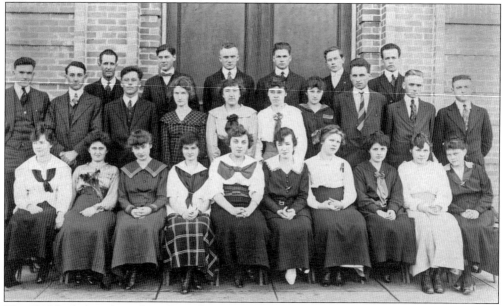

The 1916 freshman class of Pacific College sits for a portrait. A total of 51 students were enrolled that year. Those recognized in the group are Margaret Hodson, Lestia Newlin, Eva Parrett, Marjorie Hazelton, Dave Marr, and Alfred Haworth. In 1917, the annual budget of the college was $24,435. President Levi Pennington received $1,500 in yearly income. The smallest salary was paid to Russell A. Lewis, the coach, at $650 per year. (GFA)

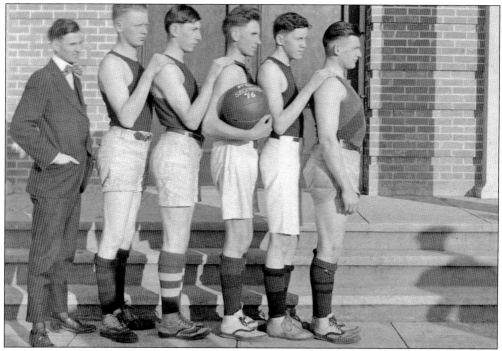

This photograph was taken around 1916 or 1917, in the same year the Bruins basketball team won the Willamette Valley League championship. Their season included a 34–25 win against the Oregon State Agricultural College (which would later become Oregon State University). (GFA)

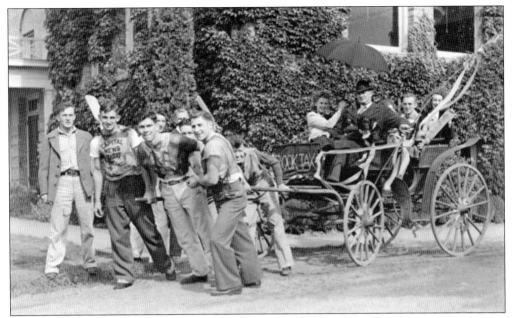

Emmett Gulley graduated from Pacific College in 1917. He taught Spanish and sociology at his alma mater and became president on June 10, 1941. In this photograph, President Gulley is being pulled in a carriage by some students. Student body president Bill Raric and Kate Coffin sit beside him. Gulley helped create the first bachelor of theology degree at Pacific. (Courtesy of Wayne Roberts.)

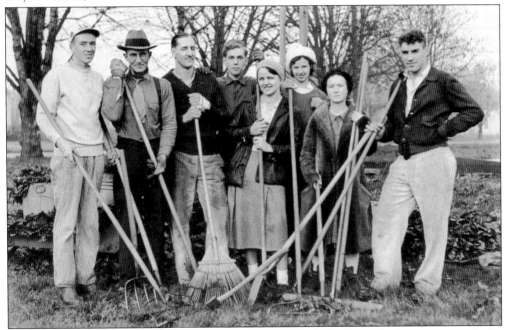

On Campus Day in 1933, the Pacific College senior class helps beautify the campus with the aid of rakes and pitchforks. During this time, three instructors resigned and the rest gave back 10 percent of their salaries while teaching more classes. The money was used to help 20 needy students with scholarships. Sadly, by 1933, only 60 percent of salaries could be paid. (GFA)

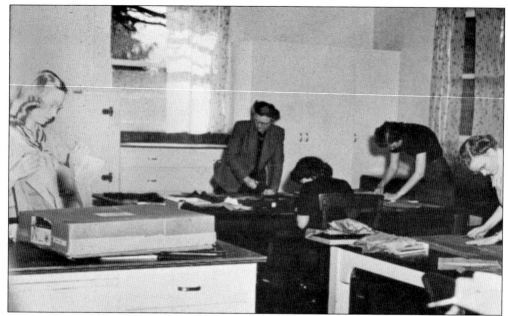

In this photograph, the home economics class enjoys a lesson on tailoring in the Wood-Mar building basement around 1951. The ladies are, from left to right, Jean White, Professor Helen (Willcuts) Street, Betty (Street) Hockett, Margaret (Dickson) Magee, and Louise Ralphs. Betty Street married Gene Hockett, also a former George Fox College student. She is sewing the going away outfit for her wedding. (GFA)

This photograph of the Pacific College Dining Hall was taken in the late 1940s. Because of World War II, attendance at Pacific College varied greatly, from a high of 129 in 1941, to a low of 85 in 1945, then rising to 161 in 1946, due in part to the GI Bill. During this time, tuition rose from $100 to $150, then to $170 a year. (FW)

Pictured is Pacific College in the late 1940s. Kanyon Hall Library sits on the right. This was a momentous time for the college. In 1949, Pacific College became George Fox College, named for the founder of the Friends movement. The college remained small until it was accredited in 1962. Today George Fox University is regularly rated among the top institutions of its kind in the nation. (FW)

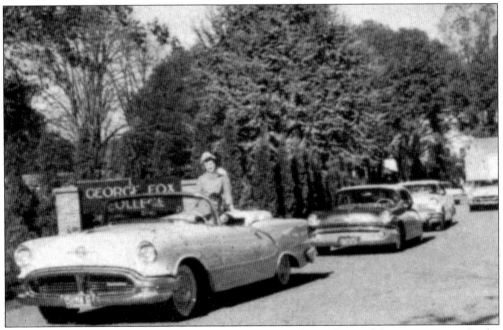

The 1958 George Fox College Homecoming Court parades in front of the campus sign. In the lead car is queen Janice Bishop. Her court following included princess Meredith Beals, princess Connie Jarvill, princess Carol Riggs, and princess Nancy Craven. The theme for that year's homecoming was "Once Upon A Time." (GFA)

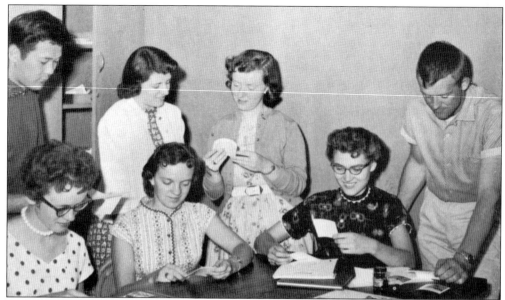

The Pacific College/George Fox yearbook is called the *L'ami*. This 1958 photograph shows the staff of the *L'ami* working on their annual issue. Pictured here are, from left to right, (seated) Betty Curryer, layout designer; Barbara Jenson, business manager; and Carol Riggs, editor; (standing) Kumasawa, sports editor; Nancy Craven, assistant business manager; Judi Retherford, assistant editor; and Harold Brown, photographer. (GFA)

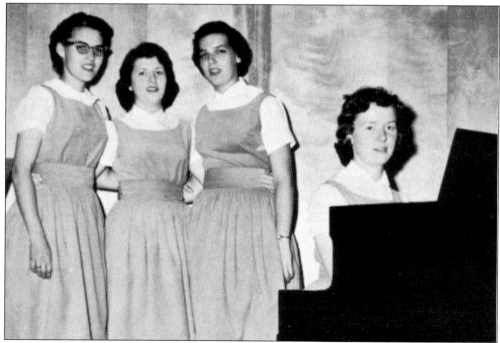

Music has been a major part of Pacific and George Fox for many years. In 1958, the Melodettes performed. Pictured are, from left to right, Carol Riggs, Nancy Craven, and Shirlene Swisher. Judi Retherford accompanies the group on the piano. Other groups that performed that year include the Triads, the Harmonairs, and James McDonnel, also known as "Deputation Chairman." (GFA)

Three
STREET SCENES

By the middle of the 19th century, the Native American practice of using fire to clear the land had ceased. When settlers first arrived in the Chehalem Valley, they were greeted by a land covered in young timber, high grasses, and spring flowers. Chehalem, in fact, is the Indian word for "Valley of Flowers." In Newberg's early days, there were only three ways to transport goods and people in and out of the valley. The main route was an old Indian trail that led from Ewing Young's ranch over the mountains toward Portland. Farmers could also use a road that led down to the Willamette River, where steamboats and canoes were used for transportation. Newberg's main route was along that old rut- and stump-filled trail, which eventually became Oregon State Highway 99W, the first paved highway created by the Oregon Highway Commission.

The lack of roads led Jesse Edwards to design a townsite on his property. He hired J. C. Cooper to do the work in 1882. Edwards's plat had 23 blocks, with First through Fourth Streets and Edwards, Meridian, Center, College, Chehalem, and Willamette Streets running north and south. In 1887, the long-awaited railroad arrived, opening up development of hotels and businesses near the train depot. Edwards began to sell lots for homes and businesses, and a town began to take shape. First Street has always been the center of business activity in Newberg. Soon electric rail tracks bisected First Street, providing a quick hour-long trip, five times a day from Newberg to Portland. Other communities began to form around Newberg. Springbrook actually started life as Hoskins, a small community two miles northeast of Newberg. Cyrus Hoskins chose the name from a spring on the side of Chehalem Mountain. In 1895, there was a general store there by the railroad tracks. Customers could come in and use the only phone for emergencies, while perusing bulk items like plug tobacco and slabs of bacon. The only building that remains from the town of Springbrook is the old school, which now sits empty.

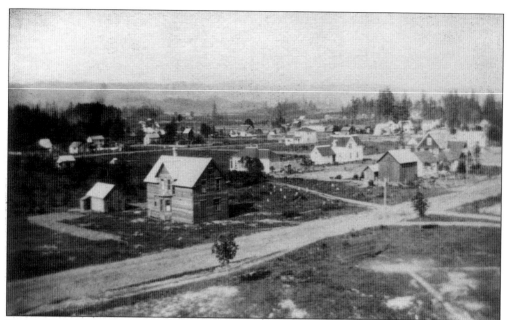

This is Newberg as it appeared in 1905, 16 years after incorporation. Prior to its charter, there were actually two Newbergs: the west end of town, dubbed "Ungodly End" ran north and south along Main Street. Mainly merchants did business here. "Godly End" was an area platted along Center Street by Jesse Edwards. The somewhat bitter rivalry was settled in 1889, when F. A. Morris was elected Newberg's first mayor. (YCHS-DL)

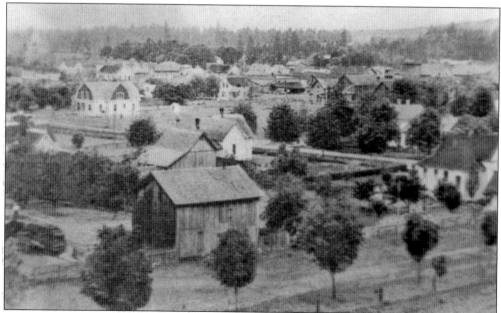

This is an undated photograph of rural Newberg. A barn sits in the foreground. Even in 1916 and 1917, many farm homes lacked modern conveniences like indoor plumbing. In those days, moles were a major problem. With training from an expert, residents caught and prepared 2,200 mole pelts for market. The proceeds provided every child in the county with roller skates, marbles, baseballs, and bats. (GFA)

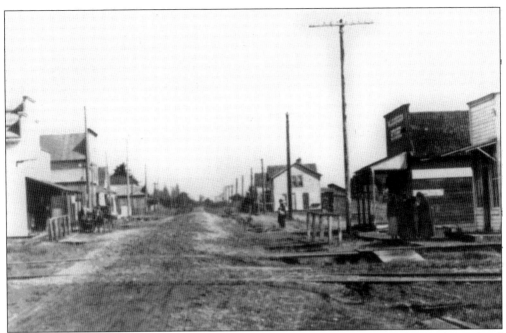

This photograph is of downtown Dundee well before any streets were paved, but after railroad tracks had been laid through town. Dundee Junction was named in honor of the birthplace of the city's founder, William Reid, born in Dundee, Scotland. Early buildings included a general store, a hotel, the stage depot, and the Dundee Fruit Grower's Packing House. (YG)

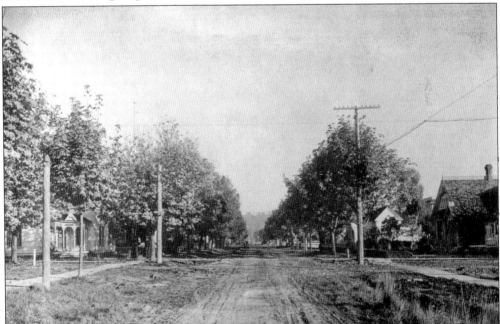

Pictured is Meridian Street before the area was paved. In Newberg's early days, the Chehalem Valley Board of Immigration envisioned a metropolis of 50,000. Advertising brought many new residents, which caused a housing shortage. Among the early homes on Meridian was that of John T. Smith, charter member of the Newberg Friends Church. (CITY)

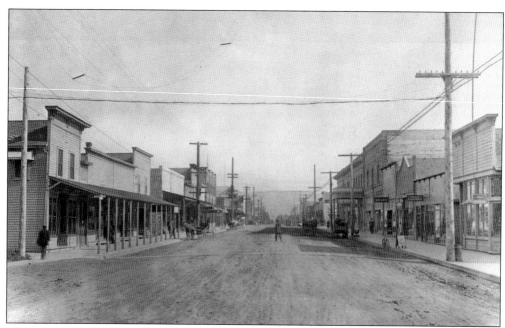

This photograph of First Street was taken in 1905. The caption reads, "On the road to a thousand wonders." Notice the wooden boardwalks and the bicycle leaning on the curb beside the sandwich board sign to the right. There is a drug store on the right, with the Imperial Hotel next door. (YCHS-DL)

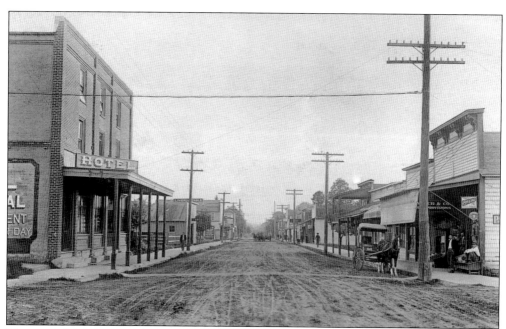

This 1915 photograph of Business Street faces west. Notice the horse drawn carriage on the right. Also in the photograph are a livery stable and the Hotel Commercial, which advertised "Special Facilities for Commercial Men," according to the *Newberg Graphic*. The livery was operated by E. E. Fleishauer. (YCHS-DL)

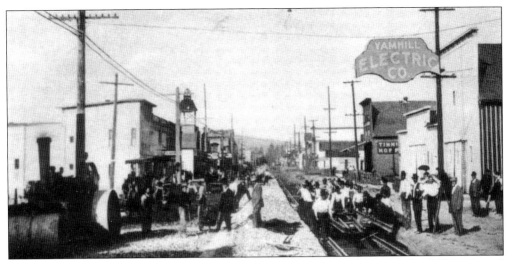

Pictured is the paving of First Street and the laying of rail lines for the Portland, Eugene, and Eastern Railway. In 1919, paving took place as part of the first paving of a highway in the state, eventually becoming Oregon State Highway 99W from Newberg to Portland. The 24 mile highway cost $6 million and was followed by a cost of $10 million for 70 miles of other roads in the county. (YCHS-DL)

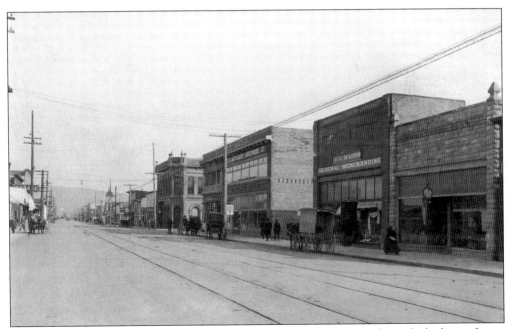

This photograph faces east on First Street. The first business on the right with the horse-drawn wagon in front is E. G. Baird General Merchandise. Next door to the east is E. B. Merchant Hardware Company, then First National Bank. A drug store sat further up the street, along with a cafe. (YCHS-DL)

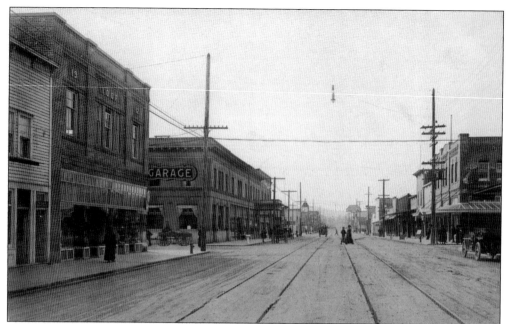

This is First Street looking west in the early 1900s. The building in the foreground to the left had a general goods store on the first floor, with an Odd Fellows hall on the second floor. For many years, it held the offices of Portland General Electric. Later Benjamin Franklin Bank and Bank of America occupied the building, until it was damaged in the 1993 Spring Break Quake. (YCHS-DL)

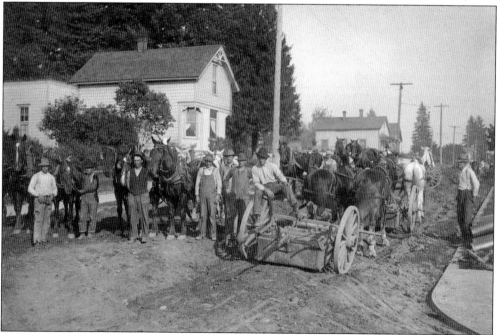

The early 1900s saw a lot of growth for Newberg and the need for better roads around town. This photograph was taken in 1915 in front of Jenny Manley's house at the corner of 5th and Main. A city road crew uses a horse team to smooth the road, possibly for paving. Jenny was related to Joseph Hess, an early Newberg pioneer. (Courtesy of Virdella Spears)

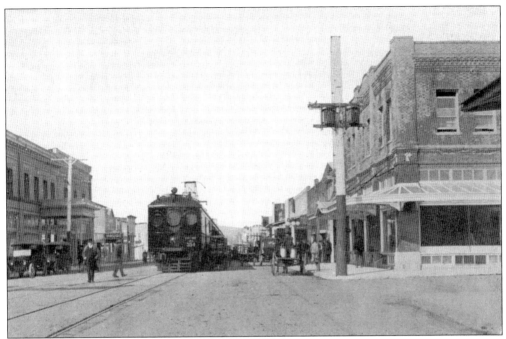

By 1912, the Oregon Electric Railway Company completed an interurban line between Portland and Eugene. In this photograph, a Red Electric takes on passengers at First Street in Newberg. Red Electrics lasted only 15 years, as many more routes were planned but only two were electrified. Newberg lies on the east side route. (GFA)

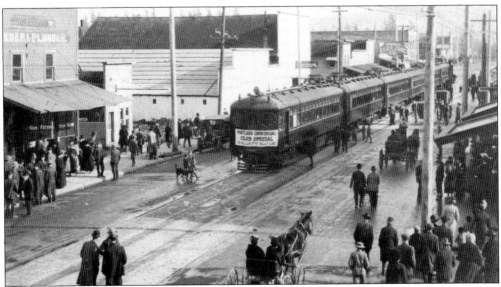

Pictured is a Red Electric on its first run down First Street in Newberg. The sign on the front of the car reads, "Portland Commercial Club Special via Willamette Valley Line." Three young boys are walking in front of the train with their dog. The train is parked in front of the Commercial Stable. (NPL)

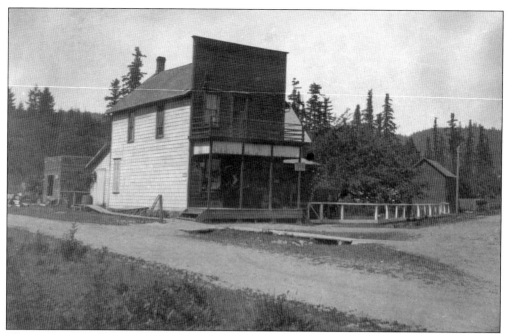

The community of Springbrook had a general store, which opened in 1890. An early settler, Cyrus Hoskins, purchased the store in 1893 and turned a portion of it into a post office. The community was initially named Hoskins but was changed to Springbrook after someone discovered another town already had the original name. (YCHS-DL)

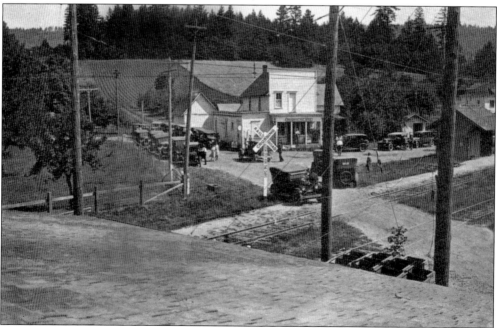

The Springbrook General Store sat across from the train depot. The Springbrook Cooperative Cannery purchased the store in 1906. It was purchased by a private individual in 1945 but burned down in 1964. Residents of Springbrook could not get to churches in Newberg during the wet winters, so they built their own in the 1890s. (YCHS-DL)

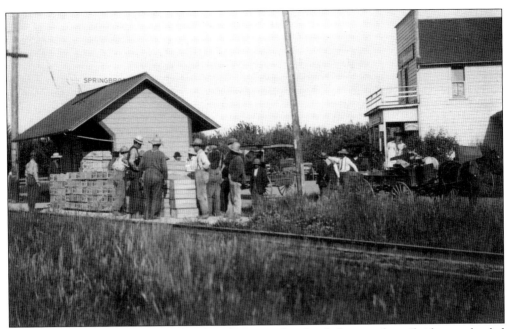

This photograph is of the Springbrook rail station. Goods piled up on the rail side were loaded into freight cars, then transported to Portland. Almost 1,700 crates of fruit per day followed this route. The narrow gauge tracks were later replaced with standard gauge. In 1914, after a series of ownership changes, the Red Electrics arrived in Newberg, providing more reliable service to Portland and Eugene. (YCHS-DL)

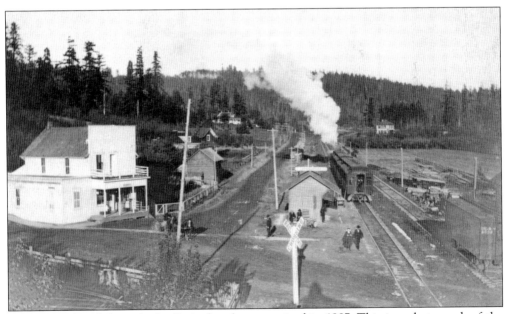

The first railroad through the Springbrook area arrived in 1887. This is a photograph of the Springbrook station. Notice the steam powered engine. It carried one passenger coach and three freight cars, providing service three times a week. Farmers from the Springbrook Cooperative Cannery used the train to transport their goods to market in Portland. (YCHS-DL)

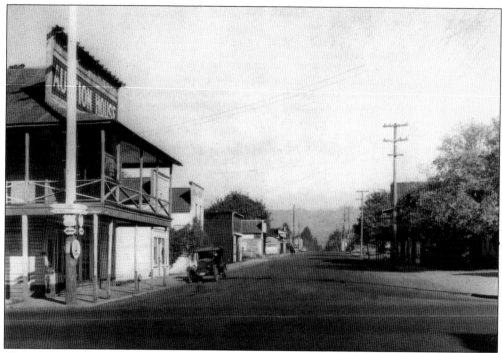

This photograph was taken at the corner of Oregon State Highway 99W and North Main Street facing north. To the left is the Auctions Works, and next door is a real estate office. Though cars can now be seen on the street and the road appears to be paved, there is a man riding a horse about halfway down the block. (YCHS-DL)

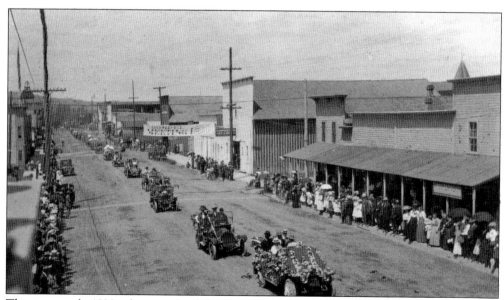

This is an early 1920s photograph of the Gospel Meeting parade. Crowds lined up in front of many of the town's businesses to cheer the floats heading down the street. The banner in the background says "Gospel Meeting" and is attached to Commercial Stable. The top of the fire station is visible behind the other buildings in the left background. (YCHS-DL)

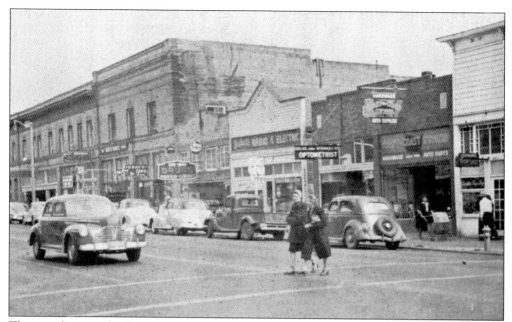

This is a photograph of First Street, published in 1948 as part of *Our Newberg*, a souvenir picture magazine. The photograph shows the Imperial Hotel, Baker's Radio and Electric, Gray's Drug Store "5¢ to $1.00," and a Coast to Coast Hardware Store. Two women cross what was still a two-way street at the time. (BF)

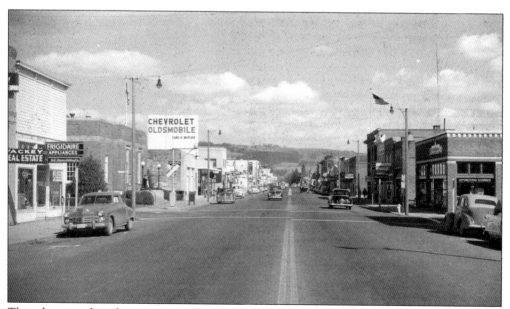

This photograph is facing east on First Street. The Post Office is on the left with City Hall across the street. Notice that First Street is a two-way street with no stoplights. The Chevrolet Oldsmobile dealership eventually moved to Portland Road. Many of the buildings in this picture remain to the present day. (TS)

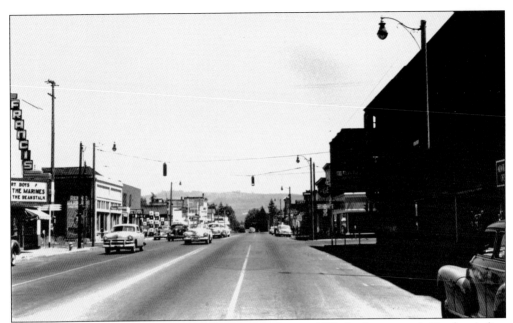

This is another view of First Street looking east, taken in 1953. In the center is Newberg's first stoplight. On the left are the Francis Theater (now Francis Square) and College Street. It appears that *Jack and the Beanstock* starring Abbott and Costello is playing. Renne Hardware occupies what is now Chapters Books and Coffee. To the right and down the street are the offices of Portland General Electric. (YCHS-DL)

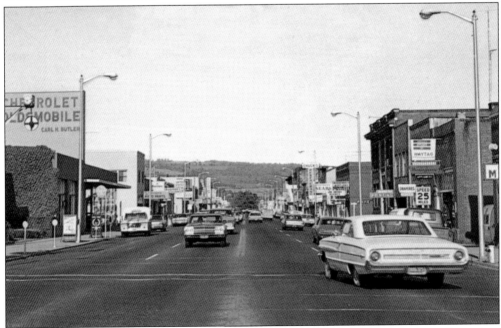

This photograph of First Street was taken in the 1960s. It is still a two way street at this point, but the speed limit has been raised to 25 mph. Butler Chevrolet sits on the left. U.S. National Bank and the Francis Theater can also be seen. Along the right side of the street are City Hall, Newberg Printing, Sears, and Chuck's Restaurant. (BF)

Four
SCHOOLS AND CHURCHES

The beginning of Newberg's organized spiritual life can be traced back to March 19, 1876. On that day, William Hobson held the first Quaker church service and Sunday school at the home of William Clemmens. So many Quakers were immigrating to Newberg that the little cabins became too small to accommodate their meetings. Fortunately, the recently completed home of David J. Wood had an unfinished upper story that the group used until 1878, when they moved to their first "Meeting House." The Wood family was also crucial to the beginnings of public education in Newberg. In 1880, Maggie Wood offered to teach 13 children in her home. Soon thereafter, "The Little White Schoolhouse" was built at the intersection of Main and Illinois, the future site of Newberg's first hospital.

By 1890, there were 274 children in the district, leading to the construction of a larger building on Sheridan Street. That building was later torn down so that Central School (now a cultural center) could be built. By the 1930s, Newberg's school district had over 1,000 students. Before high schools were constructed in Sherwood and Tigard, students from those districts attended class in Newberg.

The city's churches also expanded greatly from the early Quaker meetings. In 1885, an Evangelical Church was built and used by the Presbyterians every third Saturday. In February 1891, 12 Baptists organized that denomination's first meeting. 1892 saw the construction of a large Friends Church, which was followed by the Free Methodists, Seventh Day Adventists, and the Methodist Episcopal churches. By the 1930s, Newberg had several Friends churches and a Catholic Church, plus Presbyterian, Lutheran, Nazarene, Christian Science, Full Gospel Tabernacle, and a First Christian Church.

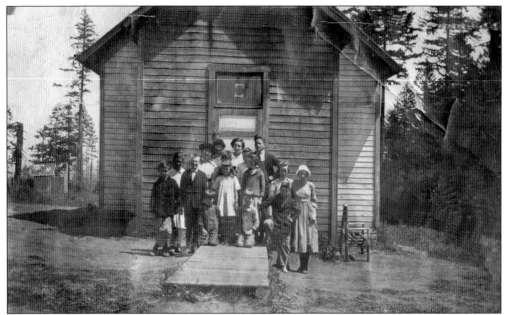

The Newberg School District No. 29 was organized on April 1, 1878. In 1880, Maggie Wood taught 13 children in her home. The seats were rough benches with no backs. In 1881, the first schoolhouse was built at the corner of Main and Illinois. This may be a photograph of that building. At that time, Newberg had about 300 students. In 1890, Ronald W. Kirk became the first superintendent. (YCHS)

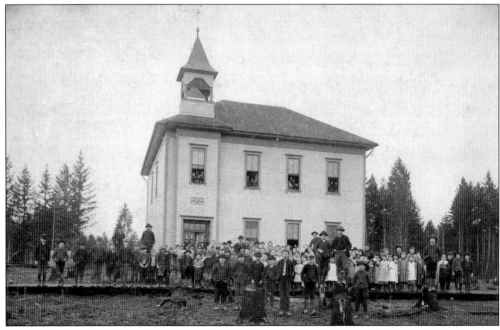

In 1878, the Newberg School District was formed from what was known as the Ramsey District. This building was completed in 1889 at the corner of Main and Illinois Streets. Horace Cox taught at the school, which was furnished with modern desks. By 1905, the building was completely occupied with two classrooms located elsewhere in town. The district had over 500 students. (GFA)

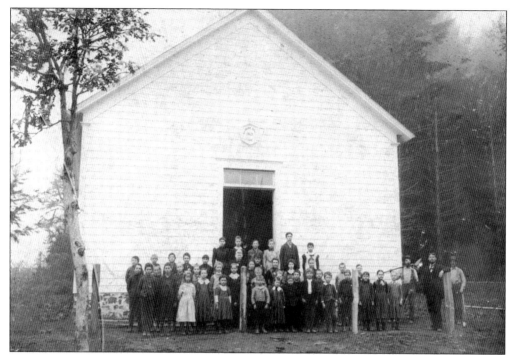

The Chehalem Center School District was located just west of the Newberg City Reservoir and just north of North Valley Road. The district's first building was completed around 1891, about the time this photograph was taken. The district grew rapidly, and an addition was added to the building. By 1962, the district had merged with Newberg. (GFA)

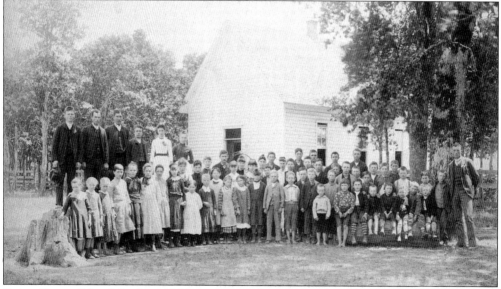

Ewing Young School, built in 1846, was originally called West Chehalem School. In its early years, the school held both elementary and secondary grades. In 1962, the school joined the Newberg School District and changed its name to Ewing Young. The original building was removed in 1953 so the current school could be built. The original bell is still displayed outside the school. (GFA)

Students gather at Chehalem Center School for a Fourth of July celebration. The district was so named because the first schoolhouse in the Chehalem Valley was located in the center of the valley in 1844. The school moved several times to be closer to the student populations. Teachers in the district included Anna Hobson, Mrs. E. Hoskins, and Joseph Everest. (YCHS)

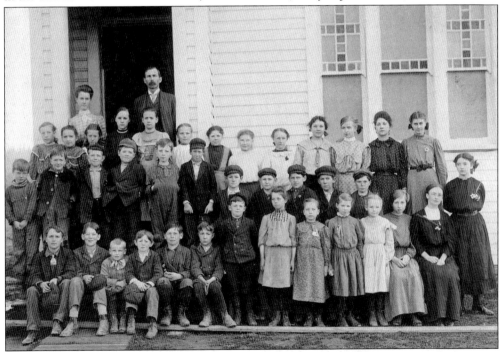

This photograph shows Springbrook Grade School for the 1906–1907 school year. Springbrook became a district of its own in 1886. District 56 was made up of other districts, including schools on Bald Peak and Gibbs. Most of the Springbrook area was eventually added to the city of Newberg, and the Springbrook School District consolidated with Newberg in 1962. (GFA)

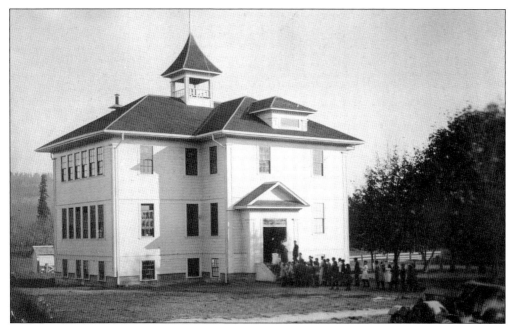

The Springbrook School District obtained this property, near the present Allison Resort and Spa, in 1890. Here students line up outside the building, which was enlarged around the turn of the 20th century. R. W. Swink and Mabel Rush taught in the district in 1907. The building burned down around 1913 or 1914. (YCHS)

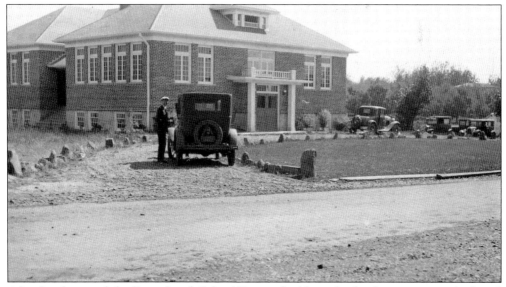

After fire destroyed the Springbrook School District building, this brick structure was built and occupied around 1935, when this photograph was taken. Early in its history, the district employed only two teachers. By 1948 a third teacher, Bonnie Liermann, began teaching classes. (YCHS)

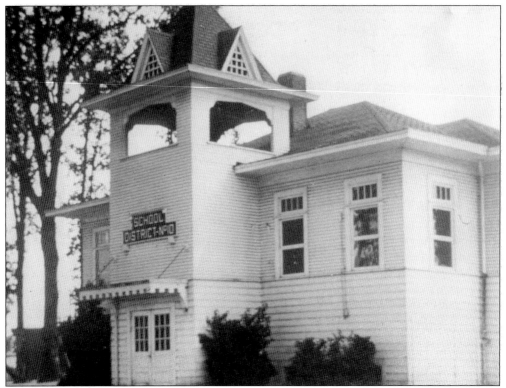

Pictured is Ewing Young School prior to its inclusion in the Newberg School District. After the new building's construction in the 1950s, the old school was used as a play area. Many of the original trees were saved and are still on the property today. The current school sits several miles west of Newberg at the intersection of Northeast North Valley and Northeast Dopp Roads. (NS)

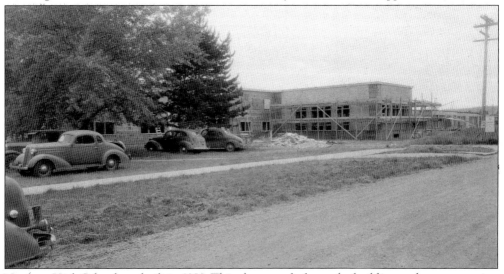

Newberg High School was built in 1939. This photograph shows the building under construction at that time. In 1964, it was renamed Renne Junior High School, in honor of Rolla Renne, who graduated from Newberg High School in 1926 and became superintendent of the district from 1936 until 1944. (NS)

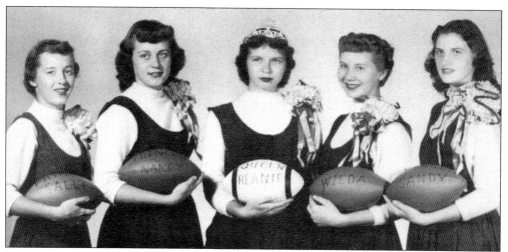

The October 16, 1954 Newberg High School homecoming court poses for a photograph. The members of the court are, from left to right, princesses Sally Renne and Nancy Adams; queen Lorene Meyers; and princesses Wilda Tucker and Sandra Eerrell. The football team actually selected court members, while the queen was elected from the court by the student body. (Courtesy of George and Goldie Leslie)

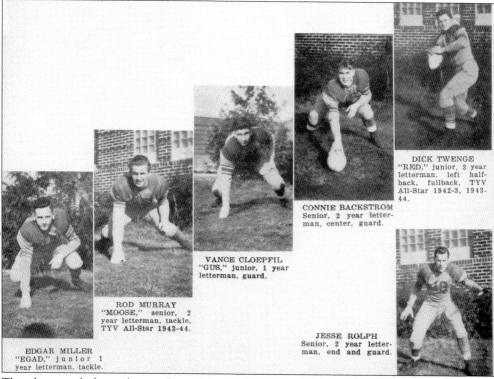

This photograph shows the members of the 1944–1945 football team from Newberg High School. From left to right are Edgar "Egad" Miller, tackle; Rod "Moose" Murray, tackle; Vance "Gus" Cloepfil, guard; Connie Backstrom, guard; Dick "Red" Twenge, fullback; and Jesse Rolph, guard. Connie Backstrum later became the owner and pharmacist of Ferguson Drug Store, while Edgar Miller became the principal of Newberg High. (NS)

Ladd Hill School was located on the Yamhill-Clackamas County line about a mile north of the Willamette River. This building was constructed in 1936. Around that time, 24 of the students came from Yamhill County, and 15 from Clackamas. Among the families represented were the Parretts. The district consolidated with the Newberg School District in 1962. (NS)

Fernwood School District was established on March 8, 1856. At that time, Sebastian Brutscher was elected clerk. The first schoolhouse was a log home, and the second schoolhouse burned down in 1928. Students were moved to the house of the school clerk, Ethel Ross. This building was finished in January 1929. In 1962, the Fernwood district consolidated with Newberg. (NS)

The Rex School District was organized in 1900. In 1903, a one-room schoolhouse was built, and later expanded. There was no running water or plumbing in the building until 1912. The outside roads were mostly dirt with patches of rock. The school was located south of Gibbs School in the gap between the Tualatin Valley and the Chehalem Valley. It consolidated with Newberg in 1962. (NS)

The Mountain Top School District was located at the intersection of Bald Peak and Holly Hill Roads. The three-acre parcel of land was donated by John Brisbine. The first schoolhouse was built in 1874. In 1887, W. W. Jaquith taught school here to 38 students. By 1916, grades one through ten were taught at the school. In 1944, the school burned to the ground. (NS)

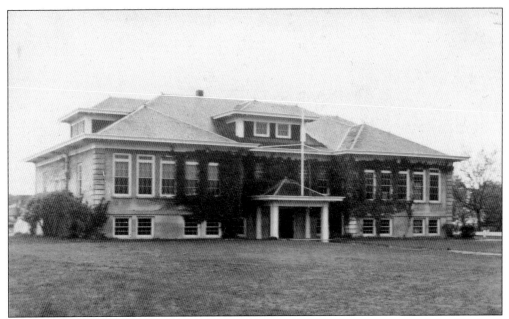

This building, constructed in 1923 and originally called Harding, was part of the Newberg School District on Wynooski Street. It held grades one through five and later became a junior high school. It was used as a Catholic school, then as a nut processing plant for the Northwest Nut Company. It is now the home of C. S. Lewis Academy, an institution with students in pre-kindergarten through eighth grade. (DC)

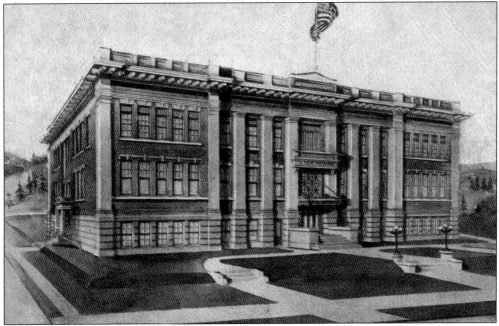

The first high school building in Newberg was raised in 1911 at a cost of $40,000. Edwards School served as Newberg's high school for 30 years, becoming a junior high in the early 1940s. It featured "laboratories, recitation rooms," plus a gymnasium with "shower baths and swimming tank." Twenty-six teachers taught 913 students in the district, 183 of which were in high school. (LM)

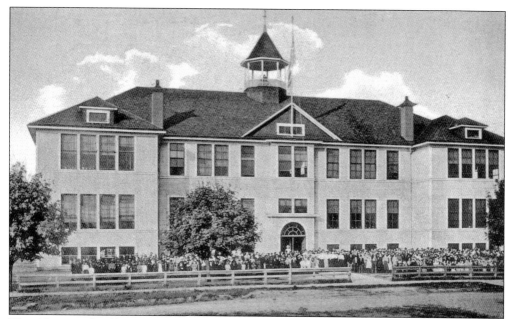

This 16-room schoolhouse was built in the Newberg district in 1905. It was thought then that the entire building would never be used; however, by 1909 so many students had enrolled that the district had to rent an additional three rooms in a vacant building in town. Newberg was the first district in the state to transport students from an outlying district (Sunnycrest District). (LM)

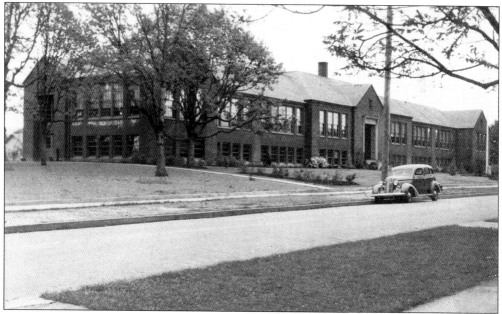

Central School was built in 1935 to replace the original structure. The federal Public Works Administration put up just over $15,000 for the project, while the other $33,000 came from the school district budget. Newberg residents, unemployed in the Great Depression, worked on the project. After closing in 1995, the school was turned into a community cultural center. (DC)

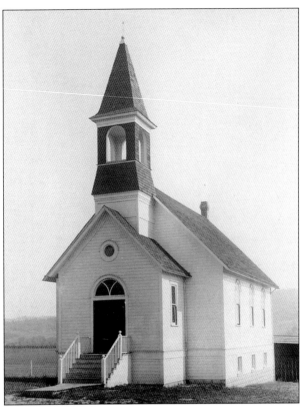

The West Chehalem Friends Church was built in 1909 as Chehalem Valley Baptist Church. George Christensen donated the land, and various fund-raisers were held, including selling space on a quilt. A few years later, the church was re-organized as the West Chehalem Community Church. In 1941, the congregation became affiliated with the Friends Church as part of the Newberg Quarterly Meeting. (WCFC)

The original St. Peters Catholic Church on North Main Street was built in 1908 at a cost of $2,000. The Right Rev. James Rauw presided. Though the building was completed, a lack of furniture delayed the opening until the fall of 1909. There were so many in attendance at the dedication, a large group had to gather under a canvas awning outside. (GFA)

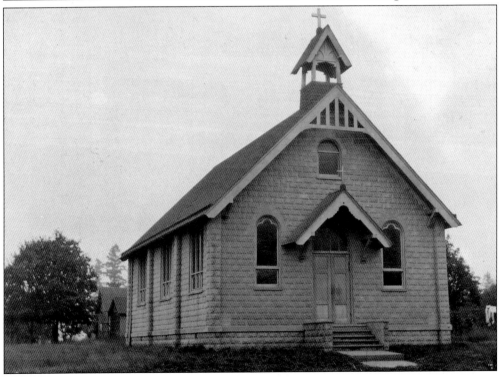

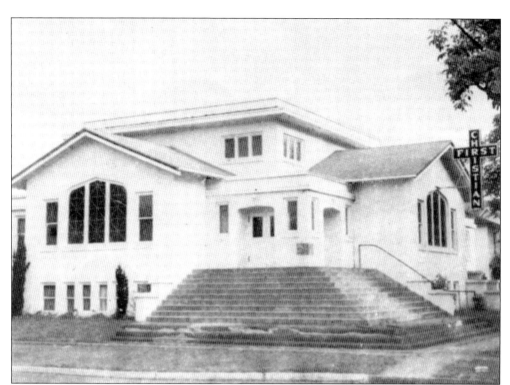

The First Christian Church was founded in 1907. This building, at the intersection of Second and College, was constructed in 1925 when the Rev. C. H. Phillips was pastor. The church then had an attendance of about 237. This 1948 photograph of the church was taken while Rev. J. Frank Cunningham served as pastor. As of publication, the church is being used by the congregation of La Iglesia Evangelica Los Amigo. (BF)

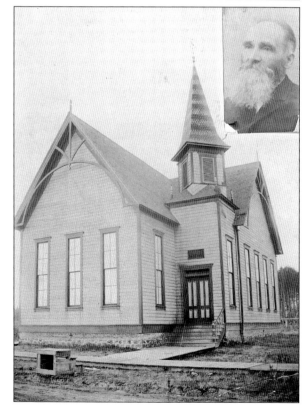

The First Baptist Church was completed in January 1892. It was located on the corner of College and Sheridan. At the time, the capacity of the church was 200 and it was built at a cost of $2,600. Rev. L. C. Davis was the first pastor of the church. Rev. Mark Noble was pastor from 1893 to 1895. He is pictured in the inset. (GFA)

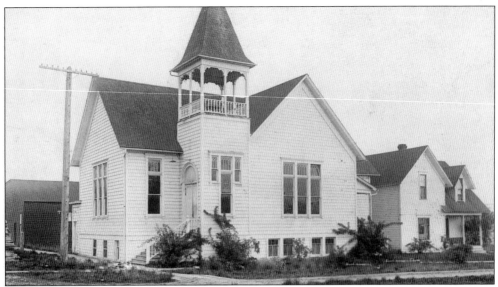

The Newberg Free Methodist Church was founded in 1889. Reverend Willie was the minister at the time. The church chose to construct a building at the intersection of North Main and North Street, which was funded by subscription, with Rev. John Watson pastoring. In 1929, the church raised a new structure on the corner of Third and Grant. (NPL)

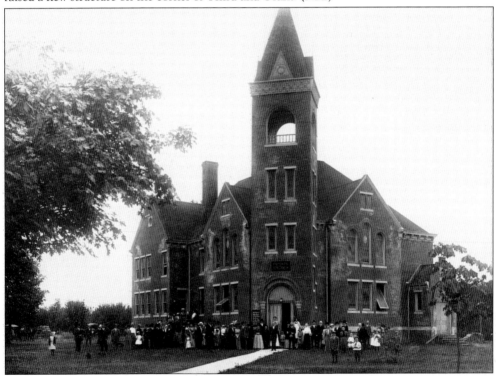

The Newberg Friends Church was built in 1892. The land on which the church stands was the original location for the Pacific Academy, a secondary school and college campus. Sitting at the corner of Third and College Streets, it is the oldest Quaker church in the Willamette Valley. During the Spring Break Quake of 1993, the foundation of the building was severely damaged but was later repaired. (GFA)

Five
CREATING A TOWN

Probably the oldest continuously operated business under the same name in Newberg is the town's newspaper, the *Newberg Graphic*. The *Graphic* began publishing on December 1, 1888. In that first issue, the list of businesses was sparse: "four general stores, two good furniture stores, two drug stores, one hardware, meat market, shoe shop, barber shop, two good livery barns, harness shop, etc." Over Newberg's history, both the number and type of businesses have changed dramatically. Early industries included sawmills, gristmills, several brick and tile factories, an ax handle factory, a creamery, a cannery, several flour mills, and an ice plant. None of these industries exist today. In the very early days, farmers grew wheat where Newberg now stands. Cyrus Hoskins planted the first prune orchard in Oregon. As late as the 1920s, growing and processing prunes was big business in Springbrook, which boasted 120 individual growers as part of its cooperative.

As more people moved to Newberg, the need for public services grew. Hotels sprang up, alongside restaurants and markets. The Newberg Electric Light Company provided electricity along 12 miles of "electric light wiring," thanks to a 100-horsepower condensing Corliss engine. The Newberg Home Telephone Company opened in 1902 with 40 subscribers and may have been the first such company in the state. The plentiful water flowing down Chehalem Mountain and the Willamette attracted several businessmen to install sawmills or gristmills. One such mill, built by the Dorrance Brothers along the river, was purchased by Charles K. Spaulding. Eventually, the Spaulding Logging Company became Spaulding Pulp and Paper. The mill still stands beside the Willamette today, though under different ownership.

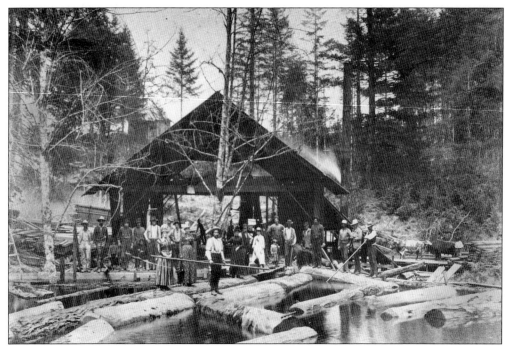

This is a photograph of the first sawmill built by Charles K. Spaulding in 1892. The mill was located on the north side of Chehalem Mountain. Spaulding had previously been partners with Jesse Edwards and Jesse Hobson in a small mill at a different location. Sam Hobson is identified as the photographer, and another copy of this picture identifies the mill as Jesse's Sunnycrest mill. (YCHS)

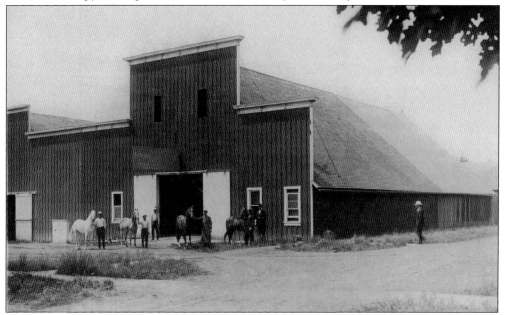

Newberg had several livery stables, including this one at First and School Streets. This photograph was taken in 1904. The man standing by the white horse on the left is George Crites. Charlie Bristow is the man in the leather apron in the center, and the man leaning against the barn is David Ireland. The sign reads, "City Livery Barn. Horses bought and sold." (YCHS-DL)

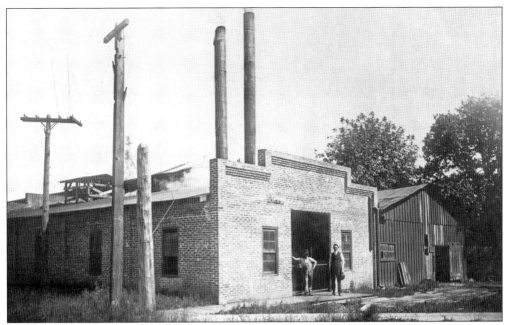

On June 1, 1901, Jesse Edwards's son Clarence began construction of the Yamhill Electric Company. Pictured here is the plant located on the northeast corner of S. Blaine and E. Third Streets in 1908. The company powered the flouring mill and started 24-hour power service. In 1909, Edwards built power lines to the city of Dayton. (TA)

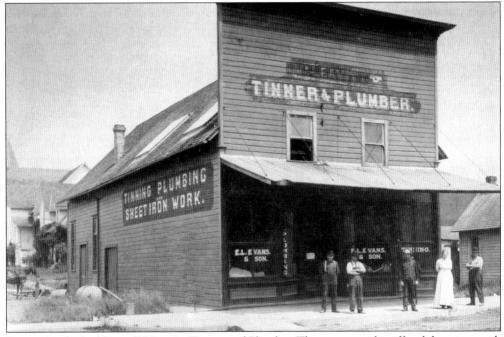

Pictured is the building of V. Leavitt Tinner and Plumber. The company also offered sheet ironwork services. In the window, another business is displayed—E. L. Evans and Son. It's likely the Evans family bought the business from V. Leavitt at some point. Tinning was the process of coating metal to keep it from corroding. The business was located at the corner of First and Howard. (GFA)

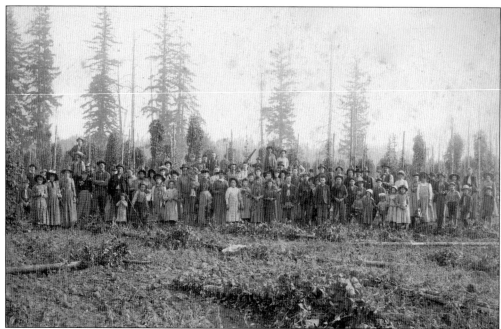

This photograph, taken around 1890, shows a large group of people gathered to pick hops around the Newberg area. Among those pictured are members of the Beaty family, descendants of Joseph Hess. Family members remember walking long distances to pick hops. There are many young people pictured, as this was before child labor laws went into effect. (Courtesy of Virdella Spears)

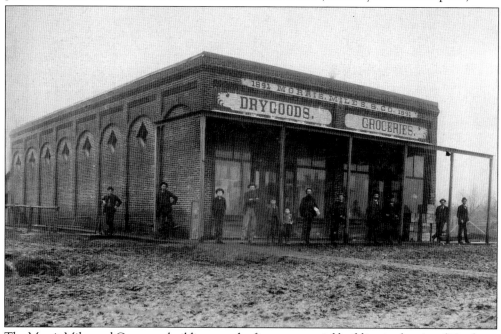

The Morris Miles and Company building was the first commercial building in the city of Newberg. The building, constructed in 1891 on the corner of First and College, housed dry goods and grocery businesses, as well as Parker Hardware, the A. C. Smith Harness Shop, Higher Ground Bookstore, a candy shop, and Chapters Books and Coffee. (GFA)

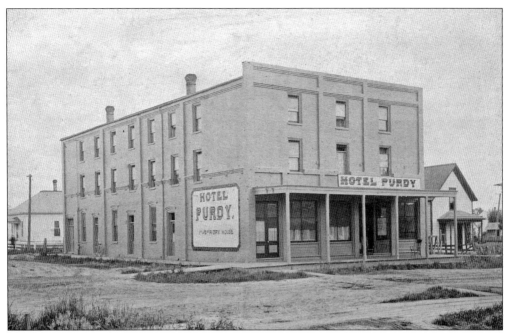

Newberg's Commercial Hotel, the Hotel Purdy, was located at the corner of Main and Sheridan Streets. Notice the wooden sidewalk, the bicycle parked along the left side of the building, and the dirt streets. The sign on the left of the building appears to say "$1.00 & $2.00 P. Day House." (GFA)

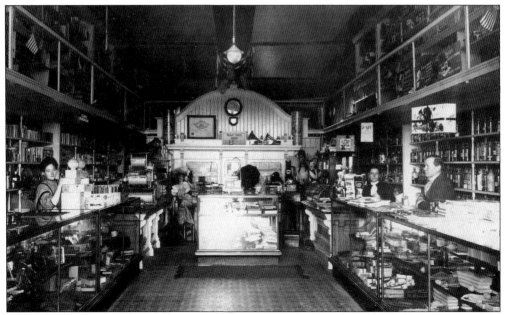

Moore's Pharmacy was established by Dr. Bert Moore and his brother Charley. The brothers started their pharmacy in a two-story frame building on the corner of Second and Center. Dr. Moore practiced medicine from the store. The pharmacy carried all kinds of products including face creams, perfumes, books and magazines, ledgers, and Kodak cameras and supplies, and also offered Edison phonographs and records. (GFA)

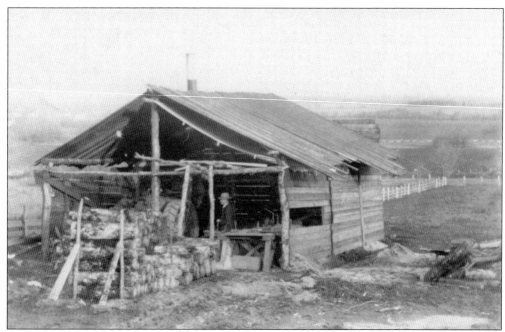

At one time, Newberg had several ax handle factories, like the one pictured above. The wood for this particular factory was cut at a small station south of Newberg near Wells, Oregon. (YCHS-DL)

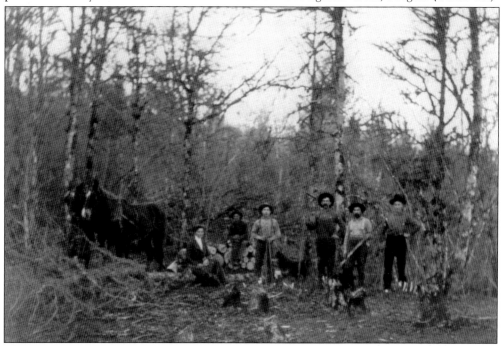

The Oregon Handle Manufacturing Company was one of Newberg's ax handle companies. In this photograph, workers are cutting down Yamhill oak, which were hauled using horse teams. J. B. Parker owned one such factory. He is described as a "bustling proprietor of one of these thriving concerns and he agrees to put out any kind of a handle that can be successfully made from oak wood." (YCHS-DL)

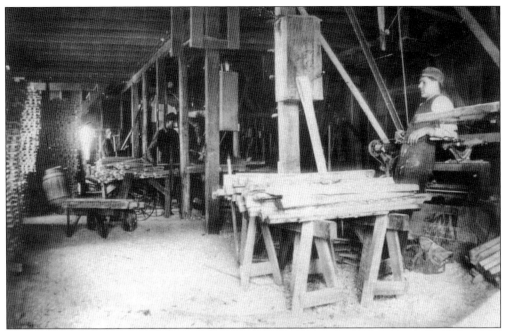

This is a view inside one of Newberg's larger ax handle factories, along with a worker leaning up against what appears to be a cutting machine. A news story at the time boasted, "Newberg has two well established factories, fully equipped with up-to-date machinery which are furnishing the Northwest trade with handles of almost every description." (YCHS-DL)

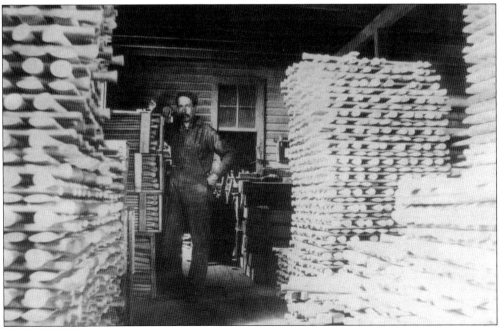

This is a storage room for one of Newberg's ax handle factories, which used Yamhill County oak to fashion handles used in the wood products industry. At the time, an advertisement described the owner as "winning good customers among those engaged in the logging industry" in the Columbia River and Willamette Valley areas. (YCHS-DL)

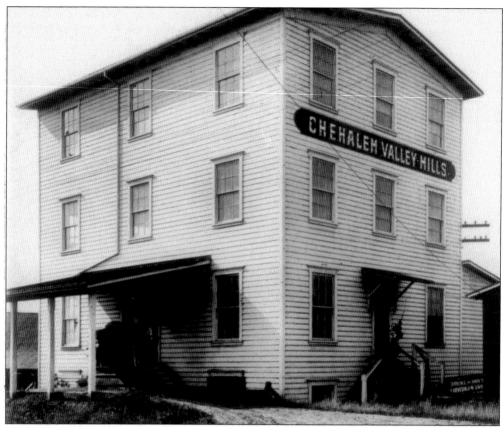

Chehalem Valley Mills was built in 1900. The flour mill had a capacity of 100 barrels a day and required 145,000 bushels of wheat yearly. The mostly pastry flour was shipped as far away as Los Angeles under the White Swan label. In 1949, the mill was converted for mixing feed, seed, grain, and fertilizer. In later years, part of the mill was used as a tack shop. (YCHS-DL)

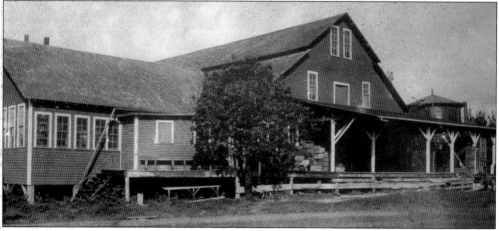

In 1906, the Springbrook Cooperative Cannery opened. The business was established by local farmers, with each purchasing a share in the company. The cooperative rebuilt the cannery after a fire in 1937 and owned it until Flav-R-Pak purchased the business in 1967. The new company closed the cannery only one year later. (GFA)

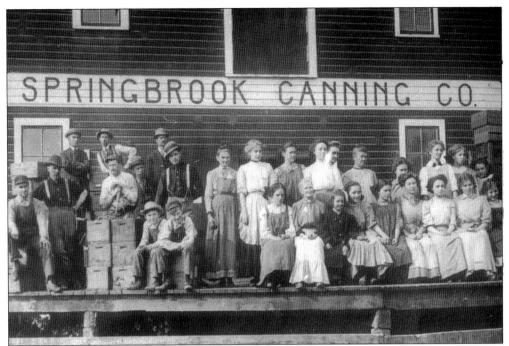

Workers pose in front of the Springbrook Cooperative Cannery. Prior to the cannery, farmers had to sell their produce fresh. Canning provided more profit per pound. The cannery produced a variety of nationally known brands such as Gold Dollar strawberries, Black Cap raspberries, and Logan berries. Production slowed at the cannery after depleted soils in the area forced farmers to replant with filberts and walnuts. (YG)

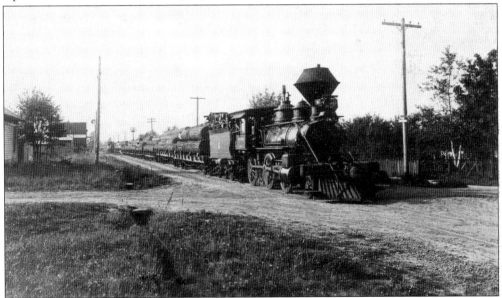

In this 1915 photograph, a train, traveling on Charles K. Spaulding tracks, carries loads of logs bound for the Spaulding Mill. Transporting logs by water became more difficult, as the mill was located away from where the trees were felled. Hauling logs by train was much more efficient, as more logs could be hauled at one time. (NPL)

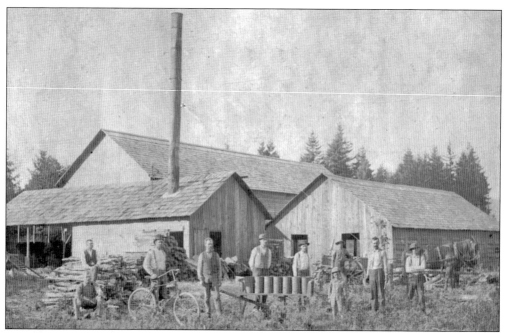

The Enterprise Tile Factory manufactured tiles for drainage. J. F. Taylor and M. P. Elliott owned the company. It was closely aligned with the local brick factories and produced tiles from 3 to 12 inches. According to one advertisement, "There is no better tile made." Workers in this photograph show off their products in front of the plant. (GFA)

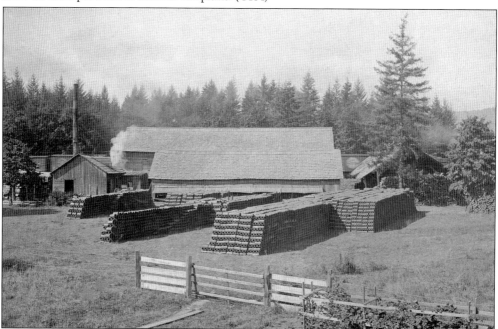

Pictured is the Newberg Tile Company around 1906 or 1907. This plant was located at the intersection of the Southern Pacific Railroad tracks and Meridian Street. Previously, a bulk oil company stood on the same site. Terracotta pipes sit in large piles outside of the plant waiting to be shipped, most likely by rail due to the plant's proximity to the tracks. (GFA)

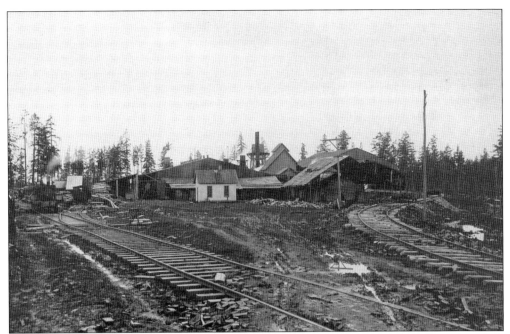

Jesse Edwards introduced the press brick industry to Newberg in 1892. The business took a while to become successful. After six years of experimenting, business began to grow until the plant supplied most of the brick for Oregon and parts of Washington. Another brick factory, the Hamnett Brick Factory (owned by James Hamnett), produced 500,000 bricks a year. (GFA)

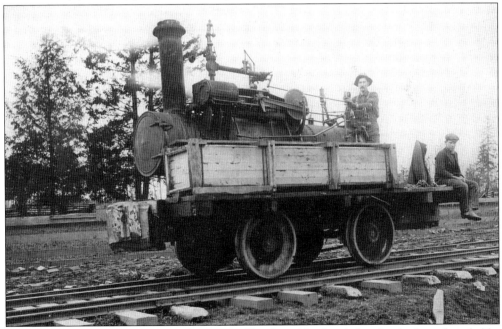

This engine was used in the manufacturing of bricks at Newberg's first brick plant, founded by Jesse Edwards on June 21, 1892. The plant, the Pacific Face Brick Company, produced pottery and crockery. At one time, the plant boasted the best brick produced anywhere in the United States. (GFA)

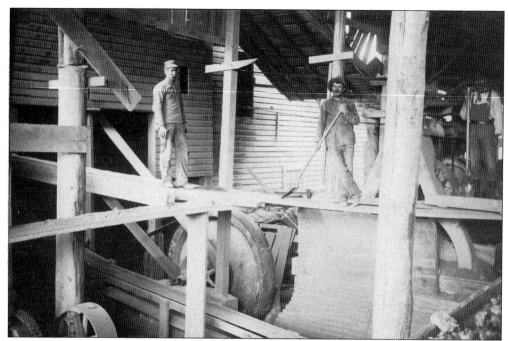

This picture, dating to 1905, shows workers posing by some of the large equipment used in Jesse Edwards's brick plant. Jesse's sons, Clarence and Oren, operated the plant after John Wetherhill sold his interest in the business back to Jesse Edwards. (GFA)

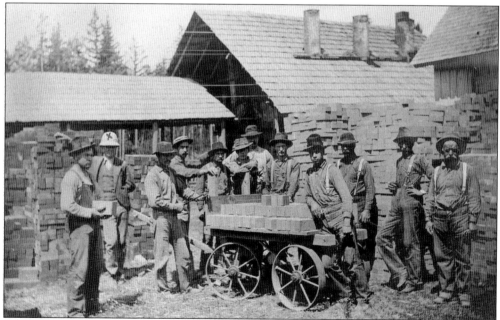

This is an early photograph of the Newberg Pressed Brick and Terracotta Company, taken between 1900 and 1905. At the time, it was the only brick plant in Newberg. An advertisement in the *Newberg Graphic* described their product: "We make white, gray, light chocolate, dark chocolate, light buff, dark buff, pink, light red and dark red colors in Roman and Standard shapes. Ornamental brick and hearth tile." (GFA)

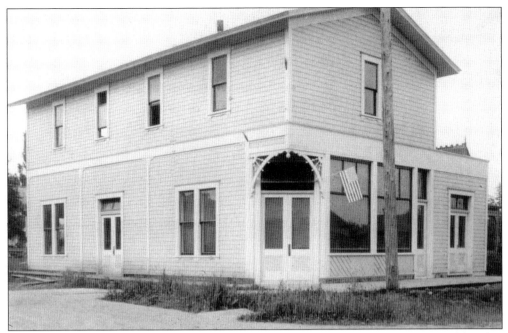

The Newberg Creamery plant was located at the corner of First and Meridian in a two-story building that cost $3,500 to construct. The Atkinson brothers would travel around the county by wagon, collecting cream from the various farms and transporting it back to the creamery for processing. An advertisement claimed the creamery was "thoroughly equipped with the latest machinery." (YCHS-DL)

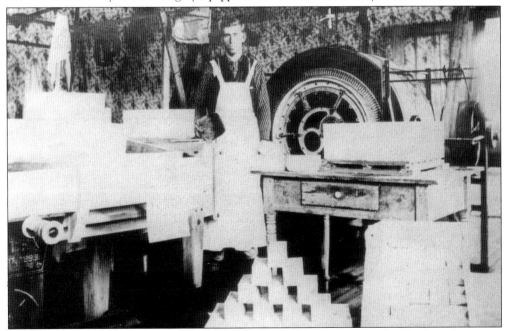

This photograph shows S. W. Atkinson standing next to equipment in the Newberg Creamery, co-owned by he and his brother. Boxes of butter appear to be stacked in front of him. The plant put out 300 to 500 pounds of butter daily under the Marigold brand. Creamery occupations had titles such as buttermaker and egg candler. (YCHS-DL)

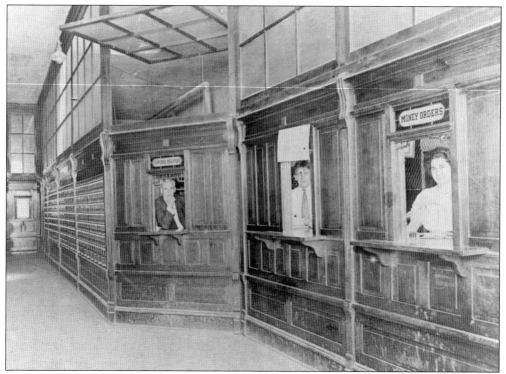

During Newberg's early days, mail came from Portland by horseback three times a week. This picture presents the interior of the Newberg Post Office in 1911 or 1912. Postmaster Charles Wilson is on the left under the sign "General Delivery," with clerk S. B. Douglas Jr. in the middle window. Money orders were purchased from the unidentified woman at the window to the right. (YCHS)

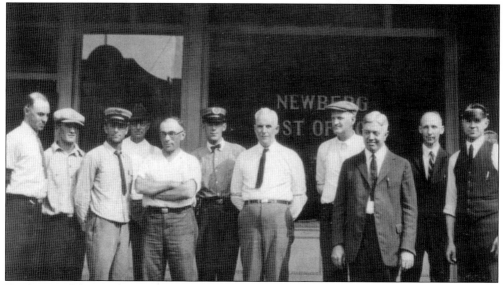

Employees of the Newberg Post Office pose in front of what is most likely the office prior to the federal post office building, built in 1936. In the photograph are, from left to right, Howard Payn, Frank Crites, Henry Cook, John Riati, Fred Tract, Roy Share, Charles Nelson, Ray Hanadi, Fred Hutchens, Ross Newby, and Frank Swartz. (YCHS-DL)

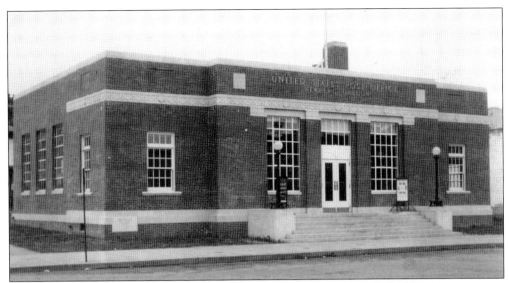

The Newberg Federal Post Office building opened on August 17, 1936. The building's construction cost $40,000. Sebastian Brutscher opened the first post office in his home in 1869. After the town was established, Jesse Hobson became postmaster. Sebastian Brutcher's grandson, Fred Hutchens, was postmaster during the opening of the Federal Post Office building. (DC)

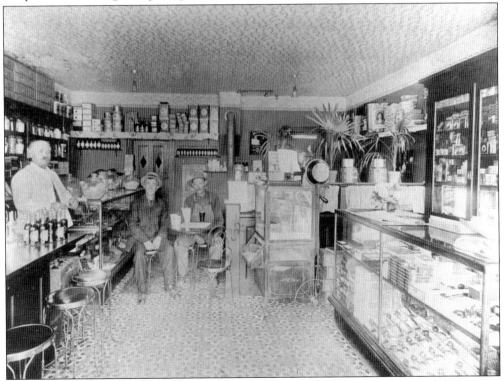

This is the Palm Confectionery in 1912. The proprietor, S. B. Dodge, stands behind the counter at the left. Glass containers of candy sit on the shelves behind him, while pieces of chocolate line the case's shelf. The right-hand case contains pipes and cigars. Cigar boxes also fill the cases on the right-hand wall. (YCHS)

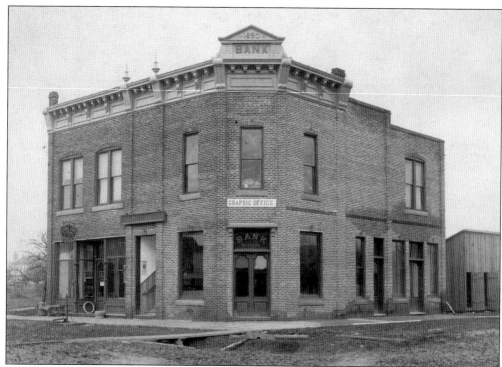

The *Newberg Graphic* was established by John C. Hiatt in 1888. The newspaper's building still stands at the corner of E. First Street and N. Meridian. A subscription cost $2 a year. Samuel Hobson purchased it and his sons edited the paper, until they were replaced by Theodore Hoover, brother of President Herbert Hoover. Hoover worked at the *Newberg Graphic* to help pay for expenses at Pacific Academy. (GFA)

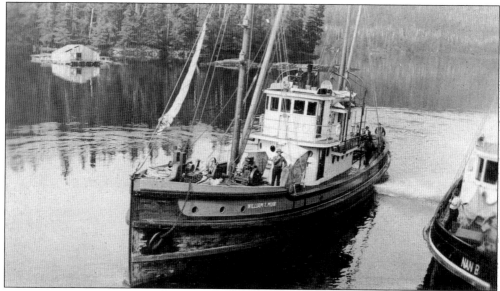

Pictured are two boats on the Willamette River, probably at Rogers Landing. The boat on the left is the *William T. Muir*. Boats hauled logs and cargo up and down the river. A crew of five can be seen on the deck, as well as a listing boathouse in the background. (Courtesy of Virdella Spears)

Six

BUILDING A CITY

The second decade of the 20th century saw the construction of many buildings along Newberg's First Street, many of which stand today. The Union Block building is one example, along with the First National Bank, City Hall, the Carnegie Library, Newberg Packing Company, and the Palace Cash Meat Market, just to name a few. Most of the buildings today aren't known by their original names, but they serve as reminders of when First Street was two-way, and newly laid tracks promised a quick ride on a quiet electric train.

As business and industry prospered, so too did the residents of the Willamette Valley. The 50th anniversary edition of the *Newberg Graphic* boasted that per capita wealth averaged $3,658 in the Valley, compared with $2,677 for the United States as a whole. Oregon led the nation in lumber production, with the C. K. Spaulding Mill employing nearly 100 workers. $62 million worth of flood control projects provided new sources of power and irrigation to the valley. No more would worries of devastating floods concern area farmers.

By the 1930s, Newberg had grown from just a few settlers to over 3,000. Wooden walkways and dirt streets gave way to concrete sidewalks and pavement. Blacksmith shops disappeared, replaced by 20 service stations and garages. Entertainment options increased as well. Ted Francis arrived in the area and purchased one motion picture theater and constructed a second. The Francis Theater had to be torn down after the 1993 Spring Break Quake, but the Cameo Theater still exists and offers a cinematic experience much like the one Newberg residents enjoyed in the 1930s. Three city parks and an outdoor swimming pool provided even more opportunities for outdoor recreation. Some businesses that came to Newberg during this era are still around, including Naps Grocery, Krohn's Appliance Center, Buckley Insurance, Sportsman Airpark, and the Oregon Mattress Company.

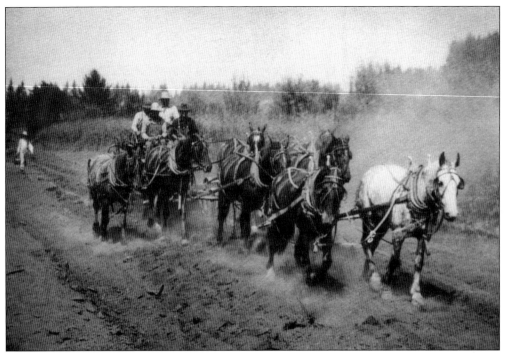

This photograph shows the grading of Benjamin Road near Springbrook. Clarence Heater, the adopted son of Ernest Heater (son of Newberg pioneer Benjamin Heater), holds the position of water boy. Many early roads around Newberg were little more than rutted, tree stump–littered trails. An old Indian trail started from Oregon City and traveled through the Heater Donation Land Claim in the Springbrook area. (YCHS-DL)

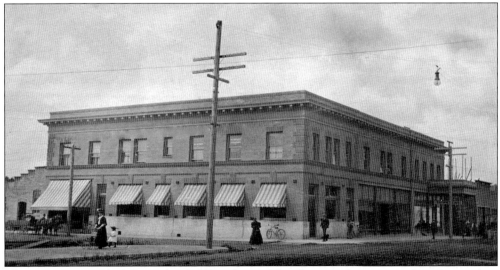

This is the Union Block located at 612 First Street. The photograph appears to have been taken in the 19th century due to the horse and buggy on the left. The Imperial Hotel occupied this building until at least 1939. At that time, Edith Hubbard managed the hotel and offered "Rooms by the day, week, month. Furnished apartments. Hot and Cold Water." (GFA)

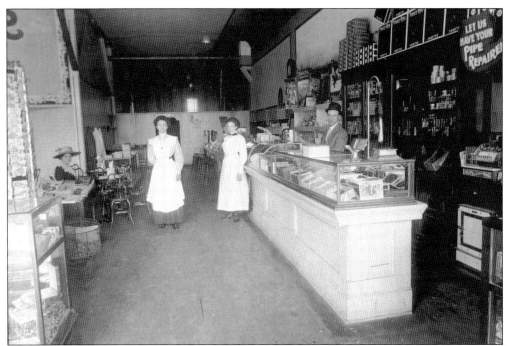

This is the Opera Grill in 1910 or 1911. To the left there was a theater. The building was later used as a pool hall. Pictured here are, from left to right, Josie Rich (seated), Mollie Bryan Van Osdol, Lilly ?, and Ara Van Osdol. A sign on the right reads, "Let us have your pipe repaired." (YCHS-DL)

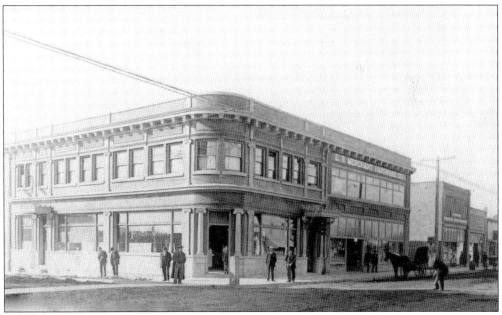

This photograph is of the First National Bank at the corner of First and Washington, built around 1910. At the time of this photograph, the building also held the E. B. Merchant Hardware Company. N. C. Christenson purchased the store in 1911. N. C. also served as Newberg's school clerk, city treasurer, and mayor. At one time, the building housed the dental offices of F. T. Wilcox and I. R. Root. (YCHS-DL)

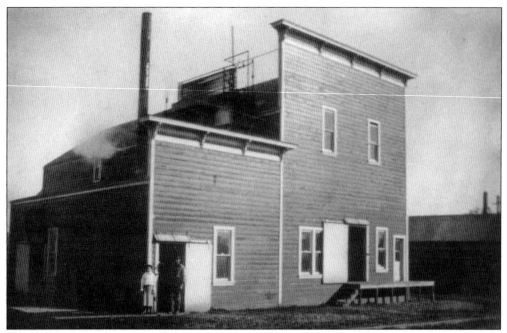

The Newberg Ice Plant, owned by the Newberg Meat Company, opened in the 1930s. The plant produced ice in the summer only, but it ran for five hours a day all year long to keep poultry, butter, eggs, and meat cold in storage rooms. The plant could provide cold storage for 3 tons of food per day. (YCHS-DL)

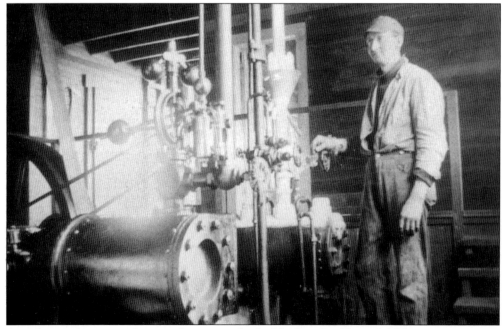

A worker tends to ice making machinery inside the Newberg Ice Plant. A 25-horsepower engine supplied refrigeration for cold storage and ice. City water was reboiled and filtered twice before being made into ice. An advertisement at the time boasted, "The institution is proving a great convenience to our rapidly growing city." (YCHS-DL)

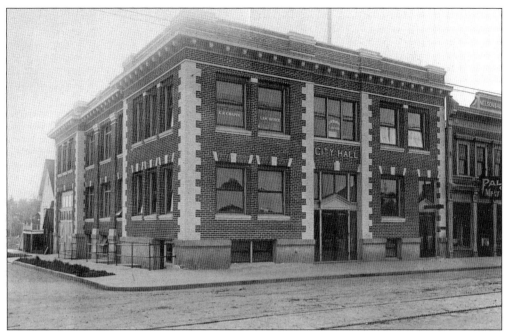

Newberg City Hall was completed in 1914. The cost of the 13,000 square foot building was $14,725. For years, the City Hall building also housed the Newberg Fire and Police Departments. Attorney C. R. Chapin's office was located upstairs. The building also contained the jail, most city departments, the chamber of commerce, and even a community room. (CITY)

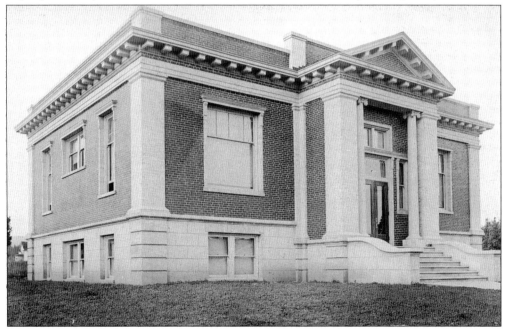

The Newberg Public Library loaned its first book on May 26, 1908. Margaret Inglis was the city's first librarian, watching over a collection housed in a corner of the YMCA building, open only from 3:00 p.m. to 5:00 p.m. and 7:00 p.m. to 9:00 p.m. On March 29, 1912, the Carnegie Library building opened its doors for a cost of only $10,000. (NPL)

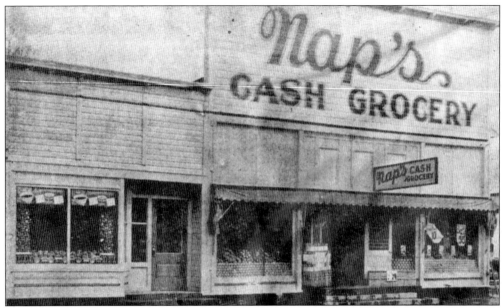

G. R. Napper created Nap's Grocery store in 1936 at First and Washington, across the street from the present Nap's. The original building was described as a "rickety pioneer frame structure." Naps spent $100,000 in 1946 to construct a new building. On May 16, 1946, it was featured on the entire front page of the *Newberg Graphic*. (GRAPHIC)

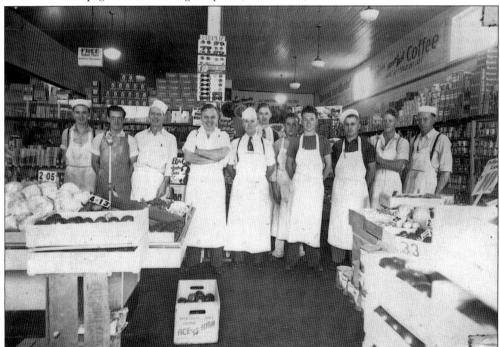

Nap's employees gather for a group photograph, which is believed to have been taken at the store's old location. Potatoes are offered at four pounds for 13¢, and lettuce at two for 5¢. Tang is advertised behind the crew, along with Safe-Ray dark glasses. A sign on the wall to the right declares that Nap's is a "One Stop Market." (GRAPHIC)

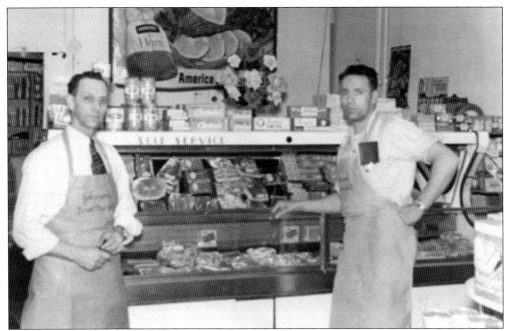

Eldon and Ralph Johnson stand in front of a counter at Johnson's Food Market in 1947. Eldon and his wife Ila were married in 1940 and operated the market in the 300 block of East First Street for many years. The Johnsons stand in front of the meat case, with a poster advertising ham and bottles of pickles on the top shelf behind them. (Courtesy of Carolyn Peterson.)

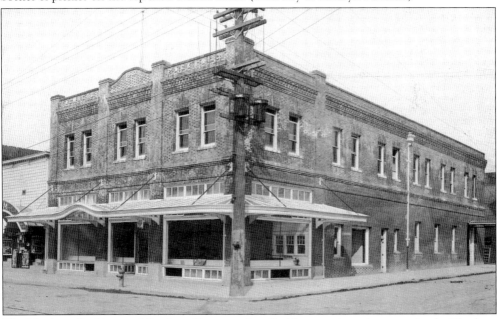

The Newberg Packing and Produce Company handled hogs and cattle grown in the Newberg area. An advertisement for the plant reads: "An extensive and very complete cold storage system is in operation affording best facilities for preservation . . . an enviable reputation has been made for their products in hams, and breakfast bacon." It was later remodeled into the Francis Theater and is now the location of Francis Square. (YCHS-DL.)

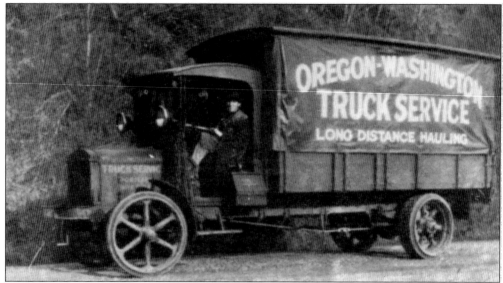

This photograph of Jack Jassey, behind the wheel in 1920, illustrates the state of truck transportation in early Newberg. The road from Newberg to Portland had just been paved, allowing for easier travel. Jassey owned and operated Oregon-Washington Truck Service, which was based in Portland and provided early interstate transportation of Newberg products. (BF: *Our Newberg*)

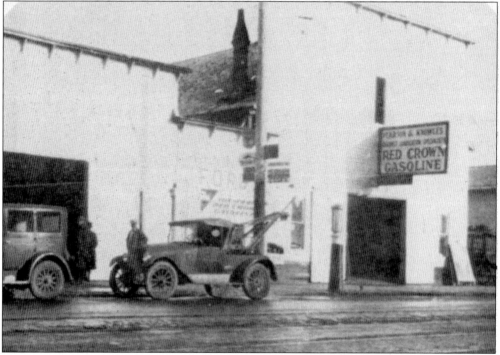

Pictured is Newberg's First Street in 1926. Rail tracks are still visible on the street, but were later covered up in a post–World War I paving project. Pearson-Knowles Red Crown Gasoline station was located at the intersection of First and School. They advertised themselves as "Correct Lubrication Specialists," and sold Hudson-Essex cars and "Genuine Ford parts." Buses replaced the Red Electric trains around 1928. (BF: *Our Newberg*)

Owner Bob Pilkenton stands proudly by a 1949 Ford Sedan outside of his car dealership, Bob's Auto Company. The dealership was located at the corner of First and Center. In addition to sales, Pilkenton provided "complete lubrication and mechanical service," according to an advertisement. He also had a separate division for auto body repairs. (BF: *Our Newberg*)

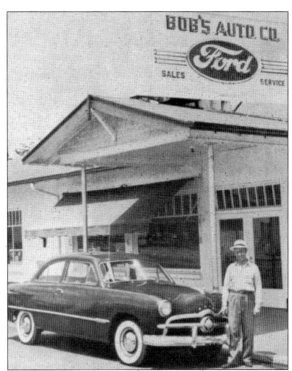

The sales and service employees from Bob's Auto Company pose for a picture. They are, from left to right, (front row) Bert Noland, Bobby Rowland, Chet Smith, Keith Ehlenfeldt, and Sam Smith; (back row) True Dyer, Bob Baker, Ray Hockstein, Bill Noyes, and Dennis King. Ferdinand Ochsner also worked at Bob's Auto Company before opening his own dealership and car care clinic in Newberg. (BF: *Our Newberg*)

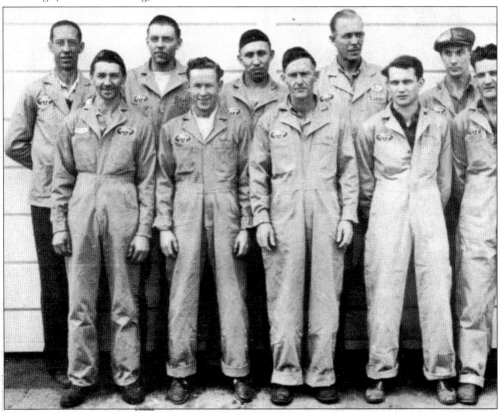

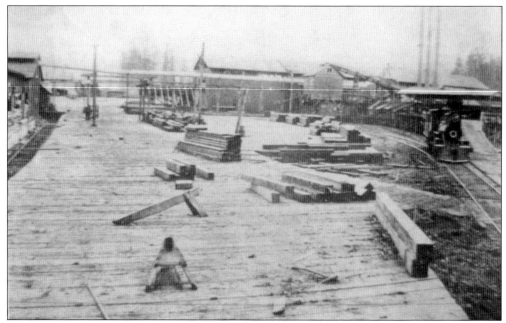

This is the Newberg Spaulding Sawmill in 1909. The company got many of its logs from the Luckiamute River in Polk County, where it owned 15,000 acres. The annual output of the mill was 35 to 40 million board feet. The plant employed about 400, and wood was hauled by rail and river. Two steamboats, the *Gray Eagle* and the *City of Eugene*, were used for this purpose. (YCHS-DL)

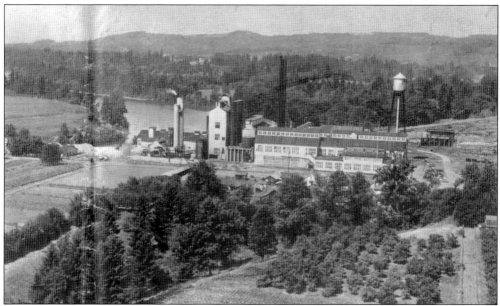

Charles Spaulding purchased a sawmill from the Dorrance Brothers in the late 1880s. Originally he used it for his logging operations. Logs were then shipped to a paper plant in Oregon City. In 1926, the sawmill was converted to the production of wood pulp. This is a view facing west, overlooking the Spaulding mill. The mill was purchased by Publishers Paper Company in 1965. (YCHS-DL)

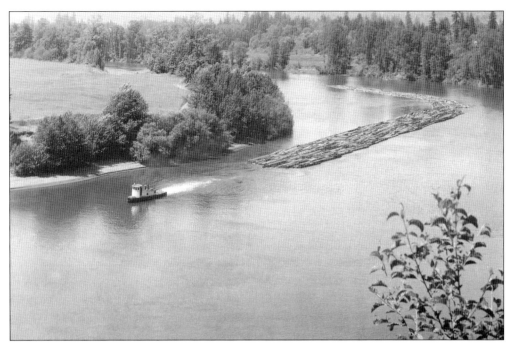

The Willamette River makes a wide turn and slows down adjacent to Rogers Landing in Newberg. This photograph, taken in the late 1940s, shows logs pulled by a tug, probably headed toward the Spaulding Pulp and Paper Company. At Spaulding, the logs would have been ground up and turned into pulp, which was used for making paper. (TS)

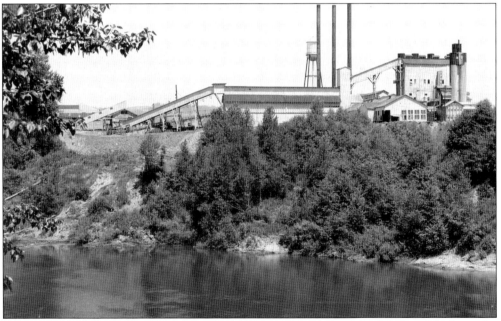

Pictured is the Spaulding Pulp and Paper Company. A well-known landmark in Newberg, the company was later sold and renamed Publisher Paper, then Smurfit, and finally Blue Heron. It is located on the bank of the Willamette River. The company began in 1926 and was the largest employer in Yamhill County. (TS)

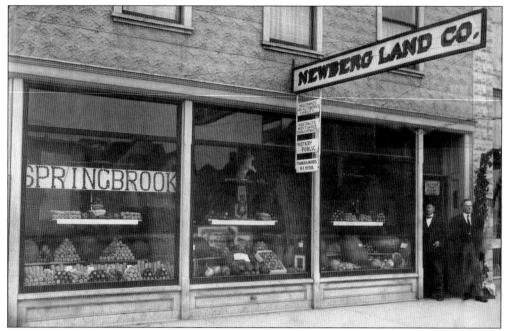

The Newberg Land Company advertised the "blessed" city of Newberg and openly invited "eastern friends" to relocate in this place "beautiful and favored beyond words to express." Francis Morris advertised homes on nearly 80 acres for $6,000. Part of "the largest prune orchard in the world" was offered for $4,500. (GFA)

An aerial photograph, taken around 1946, shows the site of Scharff Motor Freight on Portland Road. The family house sits near the road with a barn in the back. Scharff was one of the pioneers of the trucking industry in Oregon and achieved international notice for his use of lightweight and fuel-efficient equipment. The property was also occupied by a hot rod club and a tire shop. (TS)

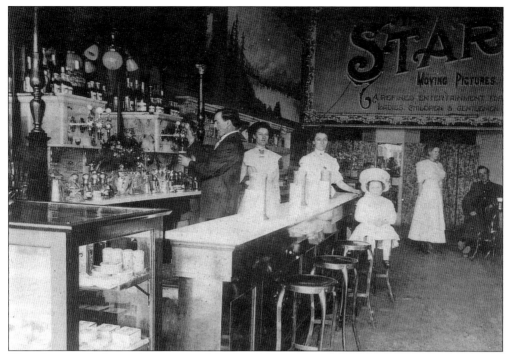

This photograph shows the interior of the Star Moving Pictures, a theater that screened silent movies. The sign in the back claims, "Refined entertainment for Ladies, Children, and Gentlemen." The theater also sold drinks on tap and other products. The building was later used as a cable television office, a comic book store, and a stock trading company. (BF: *Our Newberg*)

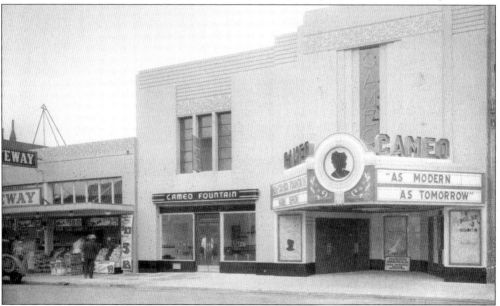

This is the Cameo Theater as it appeared in 1939. The poster on the right boasts the "Finest Equipment" used. Next door was the Cameo Fountain, to the right was Ferguson Drug Store, and to the left was Safeway. Common prices for movies during that time were 5¢ for a matinee and 10¢ for an evening show. (Courtesy of Brian Frances)

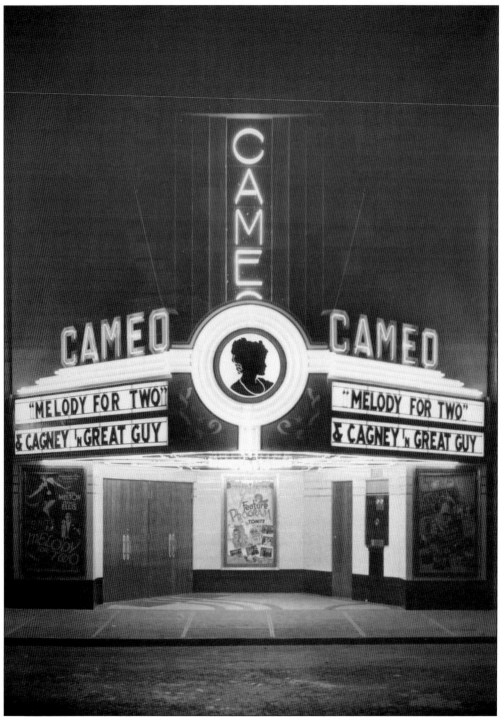

The Cameo Theater is one of the most recognizable businesses in Newberg. Designed by architect Day Walter Hilborn, it opened its doors on August 20, 1937. At the time, it was considered one of the finest theaters in the Pacific Northwest. Ted Francis purchased the Cameo and reopened it in 1941. The 600 (now 345) seat theater still operates today under the ownership of the Francis family. (BF)

Ted Francis was in large part responsible for the theaters of Newberg. In this photograph, he picks up food for his concession stand from Poppers Supply in Portland. Originally the Cameo Theater was remodeled without a concession stand, as Ted was against selling food in the theater while the movie was playing. He eventually opened a concession next door to the Cameo. (BF)

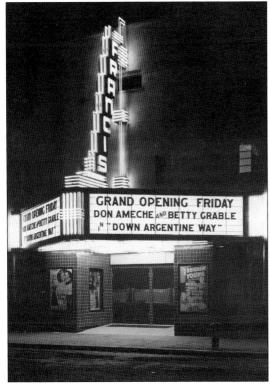

Ted Francis opened the Francis Theater on Friday, November 8, 1941, offering *Down Argentine Way* as its first film. The building was formerly a meat packing plant. The theater competed with the Cameo and eventually closed in 1984 when the Twin Cinemas opened next to the drive-in. The Spring Break Quake of 1993 made the building uninhabitable. It was torn down and is now the site of Francis Square. (BF)

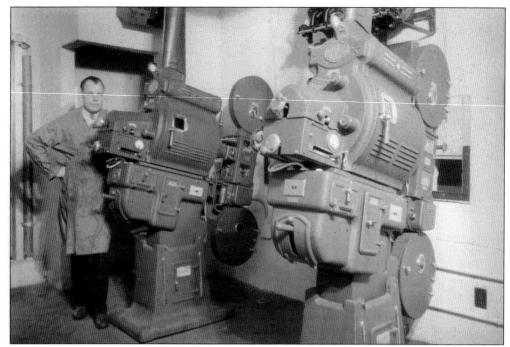

A union projectionist stands next to the two 35mm projectors at the Cameo Theater. Running one of these projectors was considered an art and science. Many states required an electrician license. The projectionist had to precisely align the carbon arc that provided the light shown through the film and onto the screen. These projectors are now on display at the Cameo. (BF)

The 99W Drive-In Theater in Newberg opened in 1953. The theater had the capacity for 300 cars. Initially, tickets were sold to the individual. The first movies shown were *She Devils* and *Under the Sahara*. The first screen at the drive-in blew down in the 1962 Columbus Day Storm. As of publication, the theater is still open and going strong. (BF)

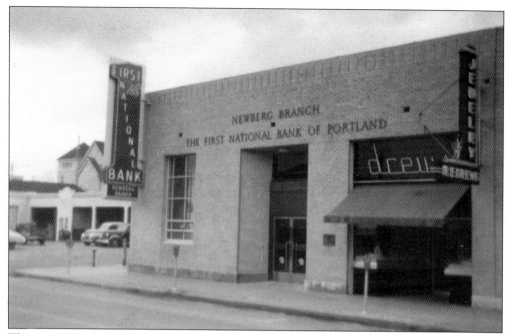

This is a 1950s photograph of the Newberg branch of the First National Bank of Portland (now Wells Fargo). It began as a branch of the United States National Bank. In 1889, the Newberg bank was organized by Benjamin Miles, Jesse Edwards, William Bond, F. A. Morris, and J. C. Colcord. (FW)

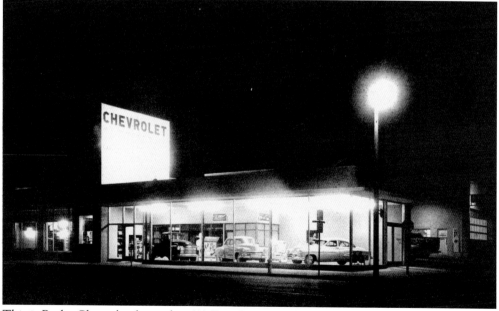

This is Butler Chevrolet, located at 411 First Street, in the 1950s. Howard Butler succeeded his uncle Carl Butler and operated the dealership, which was originally a residence and doctor's office. Beginning in 1929, an automobile dealership, service center, and a gas station operated on the property. A body shop took over the location in the 1970s. Loren Berg purchased the dealership in 1992 at its present location. (Courtesy of John K. Smeed)

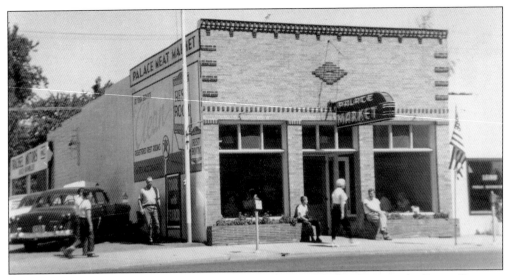

In 1900, John Wilhelmson relocated his Palace Cash Meat Market from nearby Forest Grove to Newberg. His son Charles operated the business until his retirement at age 62. Clifford Wilhelmson remembers making meat deliveries on his bicycle for his grandfather. The building, located at 209 East First, still stands. (DC)

This is Gray's "5¢ to $1.00" variety store. The caption under this picture, from the publication *Our Newberg*, says, "School girls on vacation look over a window display of study supplies at Gray's Variety store in anticipation of another academic year beginning September 15th." The store was located in the 600 block of East First Street. (BF: *Our Newberg*)

Cecil Martin's Ice Cream store was located at 706 First Street. Here, Marilyn Mills is serving customers just after the store opened. Notice the sign on the left advertising Frosty Malts for 10¢. The flavors of ice cream are listed on the right and included lemon and chocolate. It's possible Cecil himself is manning the cash register to the left behind the counter. (BF: *Our Newberg*)

In earlier years Newberg had catalog stores for both Sears and Montgomery Ward. This photograph shows customers pouring through catalogs at the Wards catalog store on East First Street. Florence Marie Mills worked as manager of this store for 30 years, retiring in 1978. In this photograph, Ruby Bates helps customers, who could also order over the phone by simply dialing "440." (BF: *Our Newberg*)

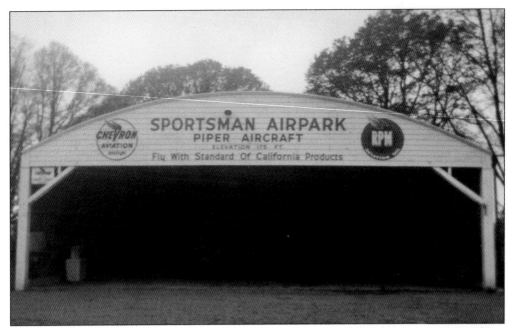

Sportsman Airpark was founded by Sam and Claire Whitney in 1946. It is one of the oldest continuously operating airports in the nation. It started out as a grass strip and a few buildings, like the hangar in the photograph above from the late 1940s or early 1950s. The sign on the building advertises Piper Aircraft and says, "Fly with Standard of California Products," referring to petroleum products. (FW)

Pictured is a member of the Pacific College Flyers Club after landing his single engine plane on the campus of Pacific College in 1949. You can see Wood-Mar Hall on the right. The plane was able to both land and take off from the campus and drew quite a lot of interest. (FW)

Seven
HELPERS AND HEALERS

Thanks to people like Jesse Edwards and William Hobson, word started spreading about a new land where people could farm and raise a family. By the end of the 19th century there were over 800 Quakers who settled Newberg, plus many other families who found the Chehalem Valley, with its balmy climate and bountiful soil, an excellent place to call home. Once frontier land turns into a township and then a city, its citizens cannot always fend for themselves. Early in Newberg's history, it became clear that important public services were needed, like law enforcement, a fire department, and medical services.

Prior to 1897, if a fire broke out in Newberg, neighbors were the only fire fighting force available. Folks would literally line up with buckets full of water. A fire at the Arlington Hotel on North Main convinced city fathers that more must be done. Hose Company No. 1 was born on May 9, 1898. Firefighters moved into their first station just a few months later. Firefighters got water from wooden fire hydrants after pulling hand-drawn hose carts. Despite great advances in equipment, Newberg didn't see its first paid firefighter until 1955, when Clarence Heater went on the payroll. 11 years later, the city added its second paid firefighter.

Newberg's first police officer was appointed in 1889 when A. G. Hayworth got the job of Town Marshal and Tax Collector. Hayworth's jail was located at the northwest corner of Illinois and Deskins. The job of Marshal soon also included the position of street commissioner. A second officer was added in 1919, paid for by the business community.

The new town of Newberg also was in need of physicians. Dr. Bert Moore practiced in a drugstore, and Dr. Horace Joseph Littlefield practiced from 1892 until his death 10 years later. Up until 1957, Newberg's hospital was actually located in a house where patients had to be carried up a flight of stairs to their rooms.

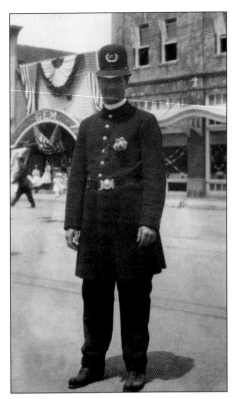

Town Marshal W. E. Thomas poses in front of the Newberg Packing Plant around 1912 or 1913. In 1889, A. G. Hayworth was appointed the first town marshal and tax collector. The first jail was built at the corner of Deskins and Illinois for a cost of $134. Marshal Wood recommended the installation of streetlights in 1892. Two years later, the title of street commissioner was added to the Marshal's job. (CITY)

W. E. Thomas, Newberg town marshal and police chief (center, seated), poses with four women and one man who comprised the first jury in Newberg that included women. Women were first allowed on juries in 1870 but this didn't occur in Newberg until 1912, at the time this photograph was taken. (GRAPHIC)

Members of the Newberg Police Department and reserves pose in front of City Hall after a training session. The man to the right of the motorcycle is Chief Russell Rogers, who served from at least 1947 to 1951. Chief Rogers established the sergeant's position and the reserve officers program. (BF: *Our Newberg*)

The police department's first "motorcycle man" was hired in 1922. The police department moved to City Hall, seen in the background, in 1927. By 1936, the entire department consisted of four employees serving a population of nearly 3,000. By 1951, the department consisted of a chief, a sergeant, a dispatcher, three officers, and eight reservists. (NFD)

Members of the Newberg Fire Department and the town's marshal pose atop and beside Old No. 3. The 1929 hose truck was first used as a snowplow in 1932. Engines like this replaced hand-drawn hose carts. The engine was restored by Ken Austin and still operates today, though not to fight fires. (NFD)

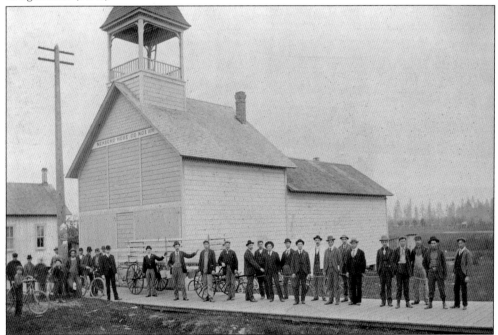

Pictured above is the Newberg Fire Station around 1901. The station was located at First and Howard. Prior to 1897, fire fighting was done by bucket brigade. The Newberg Fire Department was established on May 9, 1898, with Hose Company No. 1. The cost to build the first firehouse was $229.35. In the background is the department's original hook and ladder wagon No. 1. (NFD)

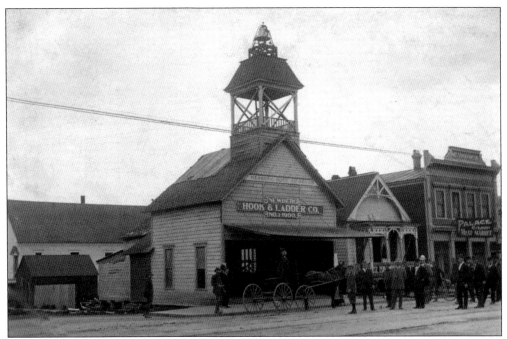

At one time Newberg had two fire departments. This one, formed about 1900, was called Hook & Ladder Company. No. 1. There was a fierce competition between the two departments as to who would arrive first at the scene of a fire. The two departments merged in the late 1920s. One company bought its first piece of equipment, a Model T Ford hose truck, in 1921 for $2,100. (NFD)

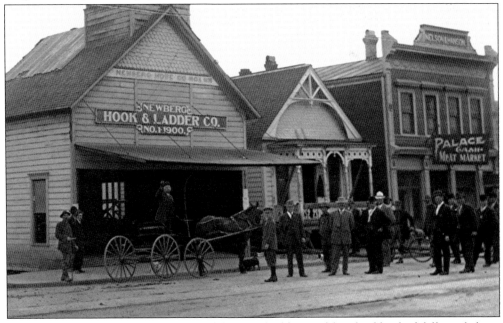

The two Newberg fire departments shared the same building and fire chief, but had different bylaws, meetings, and drills. You can see the two signs on the building for the Newberg Hose Company and the Hook & Ladder Company. A house is sandwiched in between the fire department and the Palace Meat Market. This site later housed city hall. (NFD)

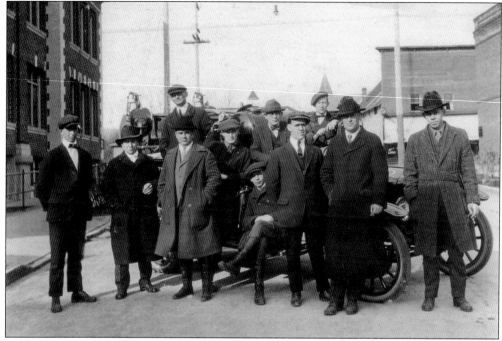

Volunteers from the Newberg Fire Department stand near City Hall around 1930. Until the merger of the two departments, fights would break out along the way to a fire to see who would have the "honor" of putting out the fire first. The department did not get its first paid firefighter until 1955. By this time, it had purchased a ladder truck and 500 feet of hose for $3,000. (YCHS-DL)

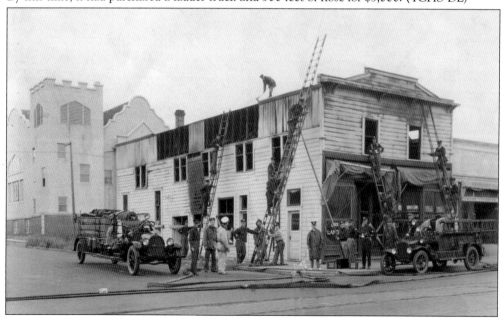

This photograph, taken in July 1928, shows the Newberg Fire Department in the mop-up stage after a fire in the Lewis Vincent Building on the corner of First and Howard. Behind the building, you can see the old First Methodist Church. Both engines responded to the blaze, including the Ford Model T hose truck on the left, and an Oldsmobile ladder truck. (NFD)

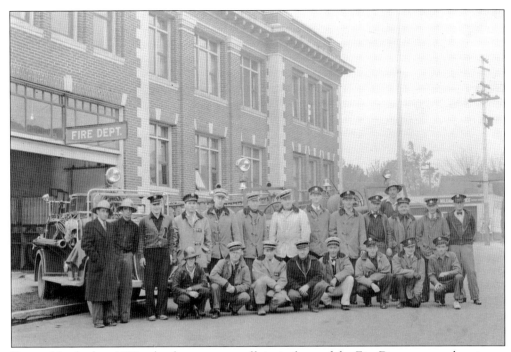

Pictured in the late 1930s, the department staff sits in front of the Fire Department when it was still housed in City Hall. The glassed-in area of City Hall is the original truck bay. The man in the center wearing a light uniform is Chief Spaulding. Clarence Heater is the man crouching second from the left. He became Newberg's first paid firefighter. (NFD)

This photograph, from the Newberg Fire Department archives, shows workers or residents at a barn on Corral Creek Road. An electric heat lamp accidentally set hay ablaze, killing many pigs, one of which is in the top left inset. Damage was set at $1,000. The fire took place sometime in the 1960s. Notice the man in the foreground attempting to put out the fire with a bucket. (NFD)

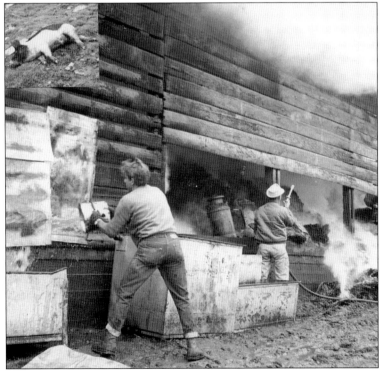

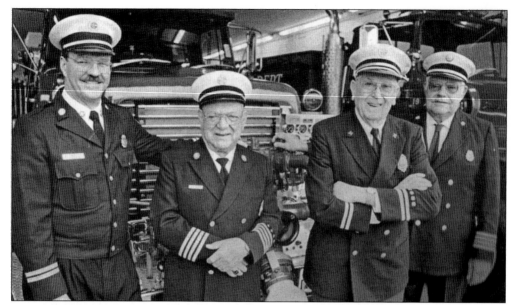

A rare moment was captured when four chiefs of the Newberg Fire Department gathered for a photograph. They are, from left to right, Michael Sherman, John Paola, Clarence Heater, and Elmer Christensen. The photograph was taken in 1996. Elmer Christensen, chief from 1965 to 1983, said one of the most memorable fires was when Newberg Ford burned down. (NFD)

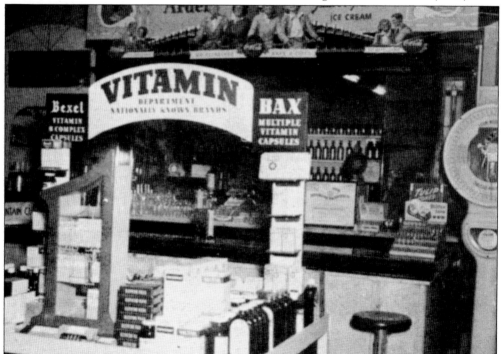

Charles Moore opened Newberg's first drug store in 1892. In 1941, Moore's Pharmacy changed hands and became Hamner Drug Store. Between 1892 and when this photograph was taken in the late 1940s, over 300,000 prescriptions had been filled by this pharmacy location. The store also sold Bax vitamins and Arder Ice Cream. (BF: *Our Newberg*)

Pictured here are two Newberg doctors and a nurse. Miss Reed stands to the left. Dr. L. H. Peek (center) had offices at 115 S. Howard Street. He came to Newberg in 1946. Dr. Stanley Kern (right) would later receive the Ed Stevens Distinguished Service Award by the Chehalem Valley Chamber of Commerce. Dr. Kern retired in 2005. (PNMC)

Members of the nursing staff at Newberg Community Hospital gather at the nurses' desk. They are Ada Clayton (Merten) CNA, who helped in the obstetrician ward, night nurse Pat Rocha RN, Naida Corder RN, Lila Rose Newby CNA, night nurse Ruth Utke RN, Leslie Clevenger LPN, Alice Webber CNA, and Eleanor Reed RN. (PNMC)

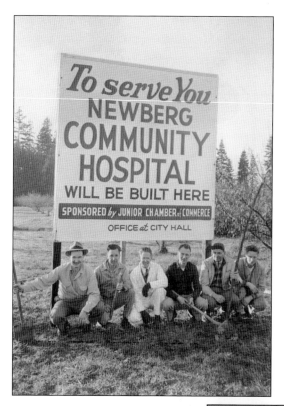

In 1946, a goal of $250,000 was set to provide for a new hospital for Newberg. After three years of fund-raising, construction began but was forced to stop in 1951 when the money ran out. Eventually a bond was passed, and enough money was raised to complete the 34-bed hospital, which opened on May 1, 1957. (PNMC)

Dr. Chester A. Bump was a well-known physician and community leader in Newberg. He lived at the corner of North College and Sheridan. In 1938, Dr. Bump served as Chief Blackcap of the Berrians, an organization that each year sponsored the Berrian Festival. Dr. Bump taught in McMinnville until 1927. He began practicing medicine in Newberg in 1934. (PNMC)

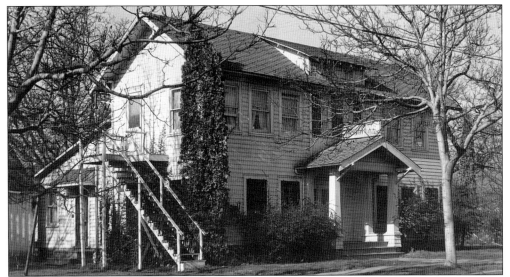

Prior to 1957, Dr. Chester Bump owned and operated Willamette Hospital, Newberg's first hospital, located in a large home on Hancock Street. Patients had to be carried up a flight of stairs, and conditions were less than ideal. It took nearly 10 years to raise enough funds to construct a modern hospital building. (PNMC)

A patient and nurse stand in front of the old hospital building, which was a 12-room house that had 19 beds with provisions for three additional beds in case of emergency. The hospital was staffed by six registered nurses and three practical nurses. The hospital was initially built as a residence. (PNMC)

Nurse Kathleen Macken helps comfort a patient at Newberg Community Hospital, which opened in 1957. It became Providence Newberg on July 1, 1994. In June 2006, George Fox University acquired the building and began using it for offices, classrooms, and meeting rooms. The new hospital was built on the eastern side of Newberg on the former land claim of Sebastian Brutscher. (PNMC)

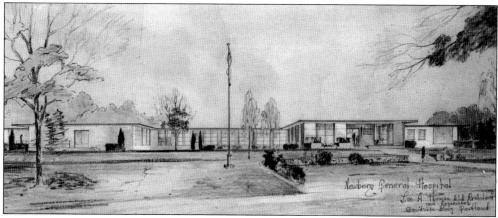

This is a conceptual drawing for the Newberg Community Hospital, which was located on Villa Road. The hospital, owned by the city, was expanded three different times. The Sisters of Providence purchased the property, which at the time had 35 hospital beds and two operating rooms. In 2004, it was named as one of the top 100 hospitals in the nation. (PNMC)

Eight
FACES AND PLACES

Many communities celebrate their most famous residents, and Newberg is no exception. Arguably Newberg's most well known person is Herbert Hoover, the 31st president of the United States. Though Hoover lived in Newberg for only a short time, he became the first student in an institution that would later become George Fox University. Not only is his boyhood home now a museum, a section of the old Portland Road (now Oregon State Highway 99W), bears his name.

The second most significant name in Newberg history, Jesse Edwards, is not often recognized outside of our community. Jesse, his wife Mary, and their four children, ranging in age from one to nine years old, arrived in Dayton from Indiana in late August 1880. Jesse's son Clarence describes their first journey to what would become Newberg: "More than half of this distance was lined with scrubby timber and stump patches. Much of the road had never even been graded, and none of it was surfaced with gravel." Despite the rustic environment, Edwards purchased a farm that no longer produced a crop. He decided the best use of the land was to establish a town site and open a store.

Though Edwards is known as the "Father of Newberg," there are many others who worked hard to create and maintain this new thriving community. People like Henry and Laura Minthorn, Harold Scharff, Florene and Garrett Cooke, and Norval Hadley formed the fabric upon which a village became a city. The city of Newberg has had many festivals over the 120-plus years it has existed. From the Gospel Meeting Parade, to the Berrian Festival, to today's Old Fashioned Festival, Newberg residents regularly gather to celebrate.

Jesse Edwards, the father of Newberg, is shown with his sons Oren, Walter, and Clarence, plus his five grandchildren. Edwards came to Newberg in March 1881. He purchased the Peter Hagey farm on the Rogers Donation Land Claim, on which he platted the city of Newberg. Edwards also donated land for Pacific Academy and served on its board. Edwards was a leader, businessman, postmaster, mayor, farmer, and preacher. He died in 1924. (TA)

Clarence Edwards sits at his desk in the chambers of the Oregon Senate. Son of Newberg founder Jesse Edwards, Clarence was part of the first graduating class from Pacific College. He went into the brick making business with his father and later founded Yamhill Light and Power. He served as mayor of Newberg and represented the area in both the Oregon House and Senate. (TA)

Miles Lowell Edwards is the son of Clarence and the grandson of Jesse Edwards. Lowell majored in electrical engineering at Oregon Agricultural College. He filed for 63 patents, mostly in aviation and pulp manufacturing. After his retirement, he worked with Albert Starr, a young surgeon at Oregon Health Sciences University, to create the first artificial heart valve. Edwards was a major donor to George Fox College. (TA)

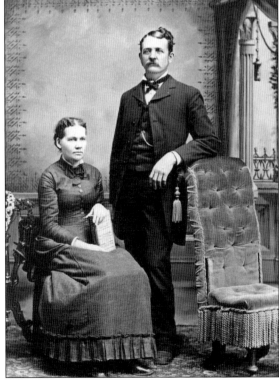

This is a portrait of Dr. Henry Minthorn and his wife Laura. In 1884, Dr. Minthorn became the first superintendent of the Newberg Friends Pacific Academy. The Minthorn's orphaned nephew, Herbert Hoover, became the first student to enroll in the new academy. Minthorn purchased the home of Jesse Edwards, where Hoover spent his boyhood. The house still stands as a museum. (GFA)

The Hoover-Minthorn house is the oldest standing home in Newberg. It was built by Jesse Edwards in 1881. From 1885 to 1889, it was the home of Herbert Hoover. The furniture in Hoover's bedroom is the actual set used by Hoover when he resided there. The house was renovated and opened to the public in 1955. (GFA)

This is a picture of Herbert Hoover from around 1877. Hoover was born on August 10, 1874, in West Branch, Iowa. His father died in 1880, followed by his mother in 1884, leaving Hoover an orphan at age nine. After living briefly with his grandmother, Hoover spent 18 months with his uncle Allen Hoover. Then, in 1885, Hoover left West Branch to live with his uncle in Newberg. (Author's Collection)

Most likely this photograph of former president Herbert Clark Hoover was taken on August 10, 1952, exactly three years prior to the opening of the Hoover-Minthorn House as a museum. Hoover, raised by his uncle Dr. Henry Minthorn, was known as "Bertie" by his friends. He attended Pacific Academy until he was 15, then moved to Salem with Dr. Minthorn. (NPL)

Former Pacific College president Levi Pennington stands with President Herbert Hoover in 1952, as the two discuss plans to turn Hoover's boyhood home (seen in the background) into a museum. Pennington corresponded regularly with Hoover between 1928 and 1962, mostly about Pacific College, disarmament, the National Committee on Food for the Small Democracies, and the Boys' Clubs of America. (NPL)

The Scharff family settled in Newberg in 1929. Harold and Georgia Scharff hold young Harold Scharff Jr. in front of their house at 2210 Portland Road. Harold owned and operated Scharff Motor Freight for many years. He was an active member of Zion Lutheran Church, a charter member of the Kiwanis club, and a longtime member of the Rural Fire Department. (TS)

Harold Scharff Jr. pulls an unidentified girl behind a toy truck at the family home on Portland Road in 1939. The truck came complete with its own horn and "Little Jim" trailer. Perhaps as an early desire to customize his vehicles, Harold Scharff Jr. added the greyhound as a hood ornament. (TS)

Many early Newberg families owned large plots of land they would farm, in addition to owning a family business. This photograph, taken around 1947, shows Harold Scharff Jr. cutting hay on the 3-acre family farm on Portland Road. Harold used the hay to feed horses, also kept on the property, which was the site of the family trucking business. (TS)

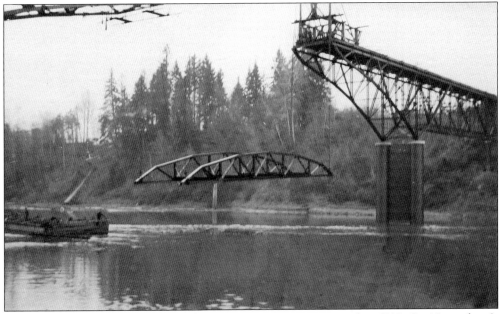

This suspension bridge over the Willamette River was constructed in 1913. On November 8, 1913, the center section of the bridge was delivered via a barge and hoisted into place. Another bridge, farther to the east along State Highway 219, replaced this bridge but it is still used as a pipeline over the river. (NPL)

The bridge in this photograph is known as the Portland Bridge. It spanned what was then City Park, now known as Hoover Park, in honor of former Newberg resident, Pres. Herbert Hoover. When the structure was built, it was the longest concrete bridge in the state of Oregon. The low area was eventually filled in and is now known as "The Fill." (DC)

Garrett Cooke was a mechanic at Bob's Auto Company, assistant fire chief, and third generation Newberg resident. Florene Cooke taught fourth grade at Mabel Rush Elementary. The couple raised 19 foster children in the Littlefield House, and provided housing for many George Fox students. Their descendants provided many photographs for this book. (DC)

The Four Flats were a barbershop quartet that started while the students attended Pacific College in 1946. Pictured are, from left to right, Dick Cadd, bass; Ron Crecelius, lead; Norval Hadley, first tenor; and Harlow Ankeny, baritone. The group won an award for "The Barbershop Champions of the Pacific Northwest," appeared with Hollywood stars, and sang before presidents. (Courtesy of Divonna Crecelius and Helen Cadd)

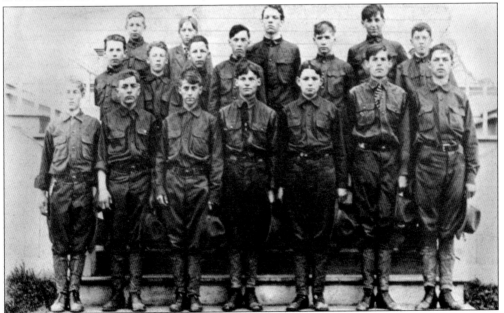

This photograph features the first Boy Scouts of America troop in Newberg. It was taken in the winter of 1912. The identified boys are (first row) Zene Hull, Harry Copeland, Tom Arney, Maynard Levitt, and Horace Duncan; (second row) Lute Hall, Frank Arney, Clifford Jones, and Teddy Leavitt. (NS)

Earlier in its history, Newberg's big annual celebration was called The Berrian Festival. Here the Berrians pose before marching in the parade. The group, formed in 1921, included a "Chief Blackcap" in the leadership of its organization. Though it disbanded in 1928, a revival in 1936 lasted well into the 1970s. When berries were no longer the main crop in Newberg, the Berrians ceased to exist. (NPL)

Pictured around 1962 is the Berrian Festival Junior Court. Competition for Berrian queen was often quite spirited. As citizens purchased goods and items from local businesses, they voted for a particular young lady to be queen. The queen would represent the organization at activities throughout the year, including riding on floats, appearing at banquets, and greeting visiting dignitaries. (DC)

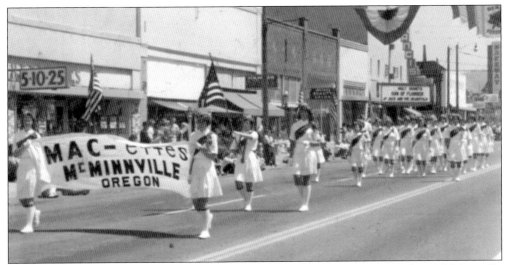

This photograph was taken during the Berrian Festival parade. The Mac-ettes from McMinnville are walking down First Street. The Francis Theater stands in the background on the left, as well as the 5-10-25¢ store. The Berrian Festival was also known as the Farmeroo and included activities such as a beard growing contest, elephant rides, and bed races. The last Berrian Festival was held in 1974. (DC)

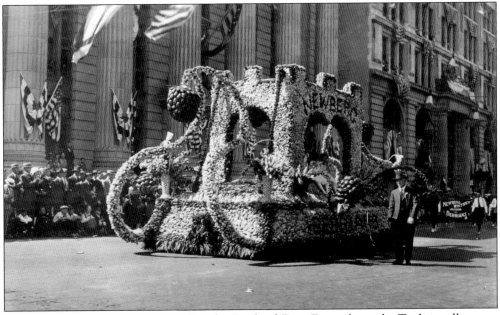

The Newberg Berrians participated in the Portland Rose Festival parade. Traditionally many Newberg residents would come out to help decorate the float, which would also run in the Newberg Berrian Festival Parade. The float would be transported with a police escort at 2:00 a.m. in order to avoid traffic. During the parade, children would often try to steal flowers from the float as it passed by. (NPL)

Viki Porter, Delores Nickols, and Marilyn Smith pose on the diving board of Newberg's outdoor public pool, which was built in 1933 at a cost of only $5,000. The pool boasted 13,000 swimmers each year. The natatorium, as it was called, was complete with dressing rooms. The 165,000-gallon pool was located at Canyon Park. (BF: *Our Newberg*)

This photograph was taken prior to 1920 at the intersection of College and Sheridan Streets. The house in the background is located at 310 North College. The driver of the buggy is possibly George Crites, while the only thing known about the other man in the picture is that he is from Sherwood. The two horses, Fox and May, were used to drive Newberg's hearse. (YCHS)

Celebrating history is an important part of Newberg, as illustrated by this marker, at the east entrance to Newberg's downtown. It was donated by Newberg Earlybird Rotary Club, George Fox University, and the city. Newberg today has over 23,000 residents. Its police department consists of 35 sworn officers, and 28 paid firefighters. Many new businesses and industries have arrived in Newberg. A-dec, the Austin Dental Equipment Company, is one of the city's biggest employers. The raising of hazelnuts has dominated area orchards. A new entrant into the agricultural scene of Newberg is the wine industry, beginning with the opening of a vineyard owned by David and Diana Lett in 1967. Today Newberg sits in the middle of Oregon wine country and features a first-class spa and resort, the Allison, built by Newberg pioneer descendants Ken and Joan Austin. (Courtesy of Tom Fuller, photographer)

BIBLIOGRAPHY

Beebe, Ralph K. *A Heritage to Honor, A Future to Fulfill, George Fox College, 1891–1991.* The Barclay Press, 1991.

A Century to Remember, Newberg 1889–1989. Newberg Graphic, 1989.

Edwards, Clarence. *Newberg as it was Fifty Years Ago.* Newberg Graphic, 1939.

50th Anniversary Edition. Newberg Graphic, 1939.

Harkness, Ione Juanita. *Certain Community Settlements of Oregon.* Graduate thesis from University of Southern California, 1925.

Jesse Edwards Died Tuesday at Midnight. unknown publication, December 18, 1924.

McIntyre, J. N., editor. *Our Newberg, A Souvenir Picture Magazine of Newberg, Oregon.* Your Town, 1948.

Miller, Jennie D. *A History of Newberg.* self-published, 1936–1938.

Newberg and Vicinity. Newberg Commercial Club, 1922 (Newberg Public Library, Vertical file: Oregon History, Newberg Business).

Newberg Fire Department, Centennial Edition. Newberg Graphic. May 9, 1998.

Newhouse, Daisy. *Springbrook, A Cooperative Community Then and Now.* self-published, 1977.

Schools of Old Yamhill. Yamhill County Historical Society, 1982.

Stoller, Ruth. *Old Yamhill, The Early History of its Towns and Cities.* Yamhill County Historical Society, 1976.

W. G. Myatt, et al. *A History of Newberg.* unknown publisher, 1954.

DISCOVER THE HISTORY OF NEARBY SALEM WITH
IMAGES OF AMERICA: SALEM

COAUTHORED BY TOM FULLER
AND CHRISTY VAN HEUKELEM

Native Americans called it "Chemeketa." William H. Willson, who laid out the city plan in 1851, called it "Salem." Both words mean "peace." Salem's central location, in the middle of the Willamette Valley's agricultural belt, made it an ideal location for the new capital of Oregon. Since then, Salem's character has largely been influenced by the presence of woolen mills, crop production, and many state institutions. Surviving devastating floods and fires in all three state capitol buildings, Salem and its people have a history of resilience, leadership, and public service.

www.arcadiapublishing.com

Discover books about the town where you grew up, the cities where your friends and families live, the town where your parents met, or even that retirement spot you've been dreaming about. Our Web site provides history lovers with exclusive deals, advanced notification about new titles, e-mail alerts of author events, and much more.

Arcadia Publishing, the leading local history publisher in the United States, is committed to making history accessible and meaningful through publishing books that celebrate and preserve the heritage of America's people and places. Consistent with our mission to preserve history on a local level, this book was printed in South Carolina on American-made paper and manufactured entirely in the United States.

This book carries the accredited Forest Stewardship Council (FSC) label and is printed on 100 percent FSC-certified paper. Products carrying the FSC label are independently certified to assure consumers that they come from forests that are managed to meet the social, economic, and ecological needs of present and future generations.

FSC
Mixed Sources
Product group from well-managed forests and other controlled sources
Cert no. SW-COC-001530
www.fsc.org
© 1996 Forest Stewardship Council

Find Your Place in History.